MANCHESTER AT WORK

MICHAEL NEVELL

AMBERLEY

ABOUT THE AUTHOR

I'm a landscape archaeologist with more than thirty years of experience. My research interests include the archaeology of industrialisation, community archaeology and historic buildings, especially textile mills and weavers' cottages. I have written extensively on industrial, landscape and buildings topics. Currently I'm Head of Archaeology at the University of Salford where as a senior lecturer I co-lead the Archaeology and Geography undergraduate degree. I am currently chair of the Association for Industrial Archaeology. Follow me on twitter – @archaeology_uos – or read my blog: www.archaeologyuos.wordpress.com.

For David George, a Cumbrian and pioneer industrial archaeologist who knows the value of Manchester's industrial heritage.

First published 2018

Amberley Publishing
The Hill, Stroud
Gloucestershire, GL5 4EP

www.amberley-books.com

Copyright © Michael Nevell, 2018

The right of Michael Nevell to be identified as the Author of this work has been asserted in accordance with the Copyrights, Designs and Patents Act 1988.

ISBN 978 1 4456 8103 0 (print)
ISBN 978 1 4456 8104 7 (ebook)

British Library Cataloguing in Publication Data. A catalogue record for this book is available from the British Library.

Origination by Amberley Publishing.
Printed in the UK.

CONTENTS

INTRODUCTION

Manchester was the 'shock city' of the nineteenth century. Those who visited it during the middle decades of the century were astounded or, like the social and political commentator Frederick Engels, more often horrified by the city's industrial face. Hundreds of cotton factories and chimneys, the narrow alleyways and overcrowded houses, were packed into the present twenty-first-century city centre. The city was prominent in Victorian literature, inspiring novels by Charles Dickens (*Hard Times*) and Elizabeth Gaskell (*Mary Barton*), books designed to raise awareness about the social injustices of industrialisation and the factory system. The 'Manchester school of economics', a term coined by the Victorian prime minister and novelist Benjamin Disraeli, with at its heart the idea of free trade, had a significant impact on Victorian and Edwardian economic and political life, while 'Manchester goods', the products of the city's cotton mills, could be found all over the British Empire.

The city was, and is, much more than a product of the Victorian age. Its origins lie in the Roman period and the city centre streets owe their names to the medieval town. In the AD 70s the Roman army established a fort on a sandstone bluff at Castlefield, overlooking a ford and the confluence of the rivers Irwell and Medlock. The settlement of Mamucium (often known as Mancunium) included not just a fort for auxiliary troops from Austria, Germany, Hungary and Spain, but also a civilian settlement, or *vicus*, under the control of the unit commander. This small market town may have been home, in the early third century, to as many as 2,000 people, making pottery, shoes and weapons for the soldiers. Over thirty metalworking hearths found within the walls of the fort testify to the beginnings of industry in Manchester. The town appears to have declined in the later third century, although the fort remained in use until the end of the fourth century (Gregory, 2007).

After the Romans left Britain in the early fifth century, this part of Manchester reverted to fields. Saxon Manchester was established around 919 when a defended settlement (burgh) was rebuilt at a site called 'Mameceaster'. This was probably the small promontory at the northern end of Deansgate overlooking the junction of the Irk and Irwell. By the mid-eleventh century this area had a church and in the twelfth century a castle, which was surrounded by the reinforced natural feature of Hanging Ditch. The town received its first grant for an annual fair in 1222 and by 1282 was a borough, or chartered town, with an elected mayor. This small town was focused on the just a few streets around St Mary's Church and the priestly college at Chethams, established in 1422: the upper part of Deansgate, Fennel Street,

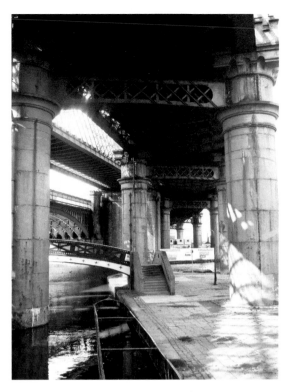

Right: The steel columns of the viaduct crossibng the Bridgewater Canal in Castlefield and leading to the Great Northern Railway Company's warehouse on Deansgate viaducts. Castlefield was the transport hub of the city in the Georgian and Victorian periods and its regeneration in the 1980s led the way in reinventing Manchester as a city for the twenty-first century.

Below: Reconstruction of Roman Manchester. (Image courtesy of the Greater Manchester Archaeological Advisory Service)

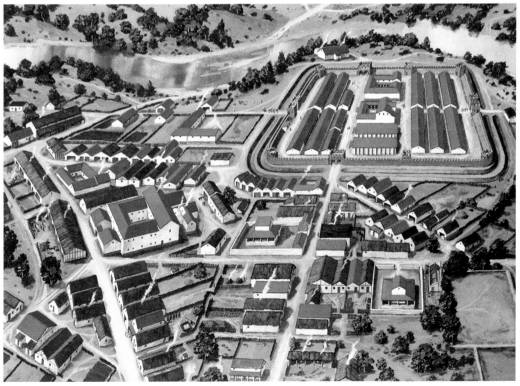

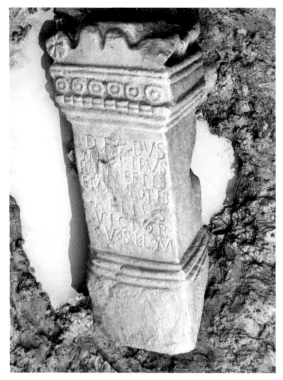

Left: The second-century AD Roman altar discovered in 2008 on the southern side of Chester Road near the Roman river crossing of the Medlock. The altar was set up by Aelius Victor, only the second named person in Manchester's history. (Image courtesy of Greater Manchester Archaeological Advisory Service)

Below: Roman Castlefield showing the Roman gardens covering part of the *vicus* or town.

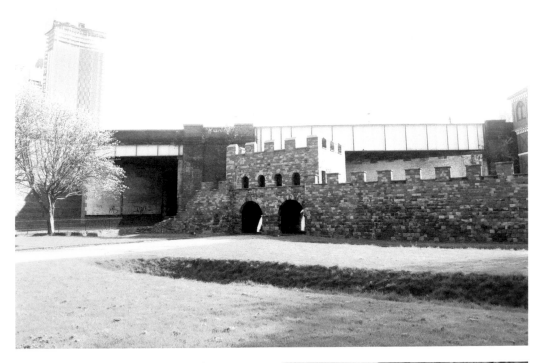

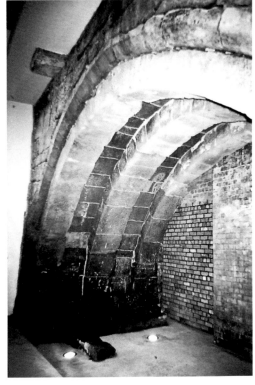

Above: The reconstructed northern gateway of the Roman fort of 'Mamucium' at Castlefield.

Right: The fourteenth- and fifteenth-century stone bridge across Hanging Ditch survives beneath Hanging Bridge Chambers.

Hanging Ditch, Long Millgate, Market Street, The Shambles and Withy Grove (Nevell, 2008). Among the medieval craft industries were leather making and shoemaking, examples of which have been excavated from the fills of Hanging Ditch.

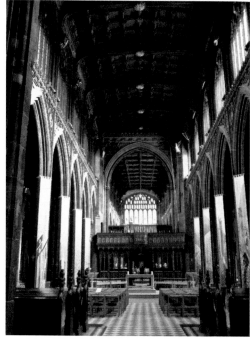

Above left: The late medieval precinct wall around the priestly college of 1422, now Chetham's Library. (Image courtesy of Greater Manchester Archaeological Advisory Service)

Above right: The interior of the nave of the fifteenth-century St Mary's Church, Manchester, now Manchester Cathedral.

Left: One of the corridors at Chetham's Library, part of the cloister of the 1422 priestly college.

GEORGIAN BOOM TOWN

While Manchester's Victorian town hall's murals proclaim the city's Roman and medieval origins, the foundations of the city's industrial greatness were established in the late seventeenth and early eighteenth centuries. A central feature of the early industrial town was the lack of control on development. The medieval chartered borough had ceased to function by 1500 and Manchester did not acquire corporate status until 1838. This meant that in the seventeenth and eighteenth centuries technically Manchester was not a town but, as Daniel Defoe described it in the 1720s, 'one of the greatest, if not really the greatest, mere village in England' (Bradshaw, 1987). As Joseph Ashton explained in 1804, the absence of borough regulation '[i]nduced strangers to add their stock of property, industry, and talent to the growing prosperity, [raising] the town and trade of Manchester to its present consequence on the national scale' (Ashton, 1804). Manchester was built on free trade and a long period of proto-industrialisation based around the manufacture and marketing of textiles.

By the end of the sixteenth century, Manchester had become the most important woollen town in Lancashire. Its growing wealth and importance as a regional trading centre is reflected in a building boom. Sadly, the only timber-framed building surviving from this period is The Wellington Inn (moved from its original position in The Shambles after the IRA bomb in 1996).

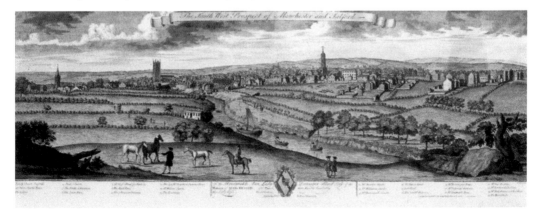

A view of Manchester from the south-west in 1734 showing the river frontage and St Mary's Church (centre) and St Anne's Church (right).

This was rented by one of the leading woollen merchant families of the late sixteenth to early eighteenth century, the Byroms. The town's population doubled between 1563 and 1664, from around 1,800 in the township to around 3,690, almost all living in the town. Thereafter, Manchester expanded rapidly. Between 1664 and 1773 the population increased sevenfold to around 23,000, driven by the shift from woollen to cotton cloth production, mostly undertaken by spinners and weavers living in cottages along Market Street and Deansgate.

From the latter part of the seventeenth century, the city was dominated by the cotton business and the production of fustian cloth. Fustian is a heavy-duty cotton fabric, the manufacture of which was predominant the eighteenth-century Manchester. Cotton merchants such as the Byroms, Levers, and Mosleys grew rich through the putting-out system, spinners and weavers working in their own homes on commission in the small towns and villages of the surrounding countryside (Nevell, 2005). These textile goods were finished by the merchant families in Manchester and then marketed in London.

The manufacturing side of the town was represented by the workshop dwelling. These eighteenth-century workshop dwellings are distinctive. Typically, they were three storeys high, had a cellar and were one room deep. The uppermost storey was designed as a workshop, with a long multi-light window to allow in maximum light. The cellar was also commonly used as a workshop. The two intermediate levels provided the family living accommodation (Palmer, 2004). A large number of this building type survive in the city's Northern Quarter, to the north of Piccadilly Gardens, along Tib Street and Turner Street (Hartwell, 2001; Rose with Falconer & Holder, 2011). Other examples can be seen on Portland Street, near its junction with Princess Street, and a row at the Deansgate end of Liverpool Road in Castlefield. The earliest examples in the city date from the 1740s. Hundreds of workshop dwellings were built on land sold by the successful merchant families of the previous century, such as the Byroms, Levers, and Mosleys (Nevell, 2011).

Examples of workshop dwellings on Kelvin Street (from *c.* 1773) and Liverpool Road (from *c.* 1788) demonstrate how these workshop dwellings functioned as proto-industrial units. A row of three houses on Kelvin Street had doorways in the cellars and attics providing access between the workshops, and attic-level external access to the rear, demonstrating that rows

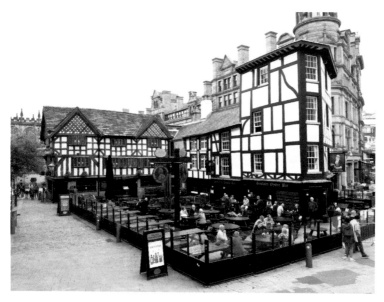

The sixteenth- and seventeenth-century timber buildings known as the Old Wellington Inn and Sinclair's, now moved to a new location by Manchester Cathedral.

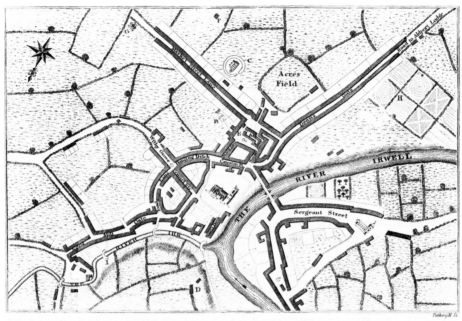

References
A Sessions House
B Cock Pit
C Radcliffe Hall
D Mr Knowles House

A PLAN OF MANCHESTER & SALFORD, TAKEN ABOUT 1650.

Drawn from a Plan in the possession of Willm Yates Esqr by John Palmer Archt 1822.

E Meal House
F Fountain
G Mr Levers House
H New Gardens
I Tanner Brolow

An eighteenth-century copy of a map of Manchester and Salford, which was originally drawn in 1650.

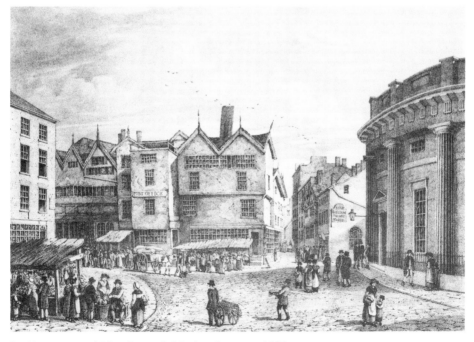

Buildings around Manchester's Market Street in 1823.

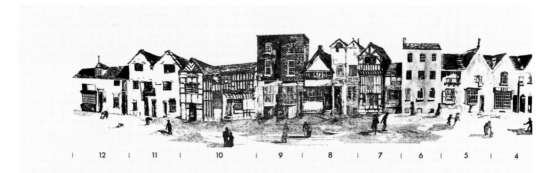

| | 12 | | 11 | | 10 | | 9 | | 8 | | 7 | | 6 | | 5 | | 4 |

LONG MILLGATE

12		11		10		9		8		7		6		5			
PRESTWICH CHANTRY								William Ravald									
								Heir of William Ravald									
		Joseph Worden 2		John Leadbeater 2		Widow Furnard	John Wigan for Anne Mosley										
		Joseph Worden 3															
...gate Occupation?		Robert Barlow	Ellen Worden 2	Edward Bosley	Hugh Stanley	Thos. Throstll 1 Peter Tyrer 2		Mr Sandiford								John	
...ver Heywood		Dr. Birch				Ralph Worsley		John Slater	Miss Lancashire	Thomas Marsden	Miss Steers	Richard Bowker	John Bayley	Samuel Birch		Benjamin Brie...	
				John Shelswedine		Mary Nichols	John Wharhead	Richard Walker			Thomas Marsden Horse Millner		John Bagshaw Soap Boiler and Tallow Chandler	John Bayley Check Manufacturer	Henry Low Distiller		
				Susanna Shelswedine SUN		Richard Townsley Brickll											
	Callaghton		Atkinson			Hurst		Travis		Steers		Heywood		Butterworth		Holb...	
...aghan	Bardesley	Combs	Kenyon	Thomas Bird	Thomas Bird SUN	John Lee Finistene	Joseph White	Aaron Jacob Slop Seller	James Riddings Taylor & Slop Seller	Dickenson	Steers	Brooks		Pickup	Benjamin Jowell	Thom...	
40		38		36		33	30	28	26		24	22	20	18	16	14	12
Kenby Ogden Undertaker		Benjamin Pearson Gas Burner Mfr.	Isaac Carmichael Merchant	James Butterworth Innkeeper		The William Cord Weaver	Peter Winnington Bacterler	John Sennor Grocer	Thomas Jones Coal Dealer	Frederick Nelson Horse Nail Maker	John Bowker Brush Maker	James Ward Provision Dealer	George Holme Innkeeper	Martha Boardman Shopkeeper	George Madd Hairdresser	Elijah St Shoem...	
		1		1		1	1	1	4	1	5	1	2			1	1
3		6				1	11	3	3	5	7		1		2		1
1				3		4	6	1					1			1	
1		1					3								1		13
...			9			8		9			10			54
						40			47		36			39			
...s Barlow, Robert Booth 1, Radcliffe 2, James Ray 2 ...al Williamson				Built 1617. Demolished 1923. Hurst Ct.		Demolished 1923.		Travis Court		Demolished 1884 Woollams Court		2 back houses being built in 1851. Back houses known as Ditchfield Court.			Built 1705 Demolished 1... Balefton (Half T...		

Left: Illustration of a typical Manchester workshop dwelling, or weavers' cottage, from *The Builder* magazine, 1862.

Above: Reconstruction of buildings along Longmillgate in the nineteenth century, showing some of the houses built by Manchester textile merchants in the seventeenth and early eighteenth centuries. (Image courtesy of Greater Manchester Archaeological Advisory Service)

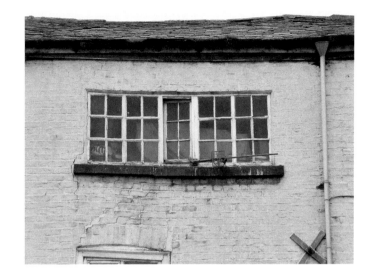

Multi-light weaving window from one the late eighteenth-century weavers' cottages on Liverpool Road, Manchester.

Late eighteenth-century weavers' cottages on Liverpool Road, Manchester. These were built in the 1780s and occupied by fustian weavers.

of such houses were built as a series of working units. In contrast, the row of eight houses on Liverpool Road appear to have been built as individual cottages, though each had an attic with a long multi-light window and cellar workspaces. These workshop dwellings were the residences of skilled workers employed on hand-powered machinery – firstly looms, later spinning jennies – on the putting-out system. The Kelvin Street properties were built by a Mr and Mrs Manchester, fustian manufacturers. Fustian cutters and weavers are recorded as living on Liverpool Road (then known as Priestner Street) in 1800 and as late as 1821.

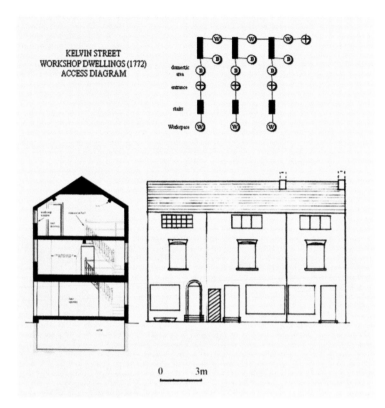

KELVIN STREET
WORKSHOP DWELLINGS (1772)
ACCESS DIAGRAM

Layout of the
c. 1773 fustian
weavers' cottages on
Kelvin Street.

TEXTILE MILLS

In the last twenty years of the eighteenth century the city's industrialisation took off with the construction of thirty-three water- and steam-powered textile mills. This mill building boom turned a regional manufacturing town into the world's first industrial city based around the mass manufacturing of cotton thread.

The city's first cotton mill was built in 1781–82 on Shude Hill by Richard Arkwright, a textile industrialist and inventor. Arkwright (1732–92), working with clockmaker John Kay, had succeeded in producing a machine capable of spinning cotton yarn, which he patented in 1769. This became known as the waterframe once it had been adapted so that it could be powered by a waterwheel. In 1771 he built a water-powered cotton-spinning mill at Cromford, Derbyshire, to house this new technology. In 1775 he secured a patent for a rotary carding machine, a key part of the preparatory process for spinning cotton, which transformed the raw cotton into a cotton lap that was then suitable for spinning. By 1785, when Arkwright's patents were revoked, over 150 cotton-spinning mills had been built in Britain using his designs and system of working. This marked the birth of the industrial factory system.

Arkwright's Manchester cotton mill was part of a building programme that saw him establish mills in Derbyshire, Lancashire, Nottinghamshire and Scotland. Manchester, as the centre of the cotton trade, was an ideal place to showcase his new mill technology. Furthermore, the local merchant class were opposed to his exclusive patents so it was also a chance to demonstrate the efficiency of his new manufacturing system.

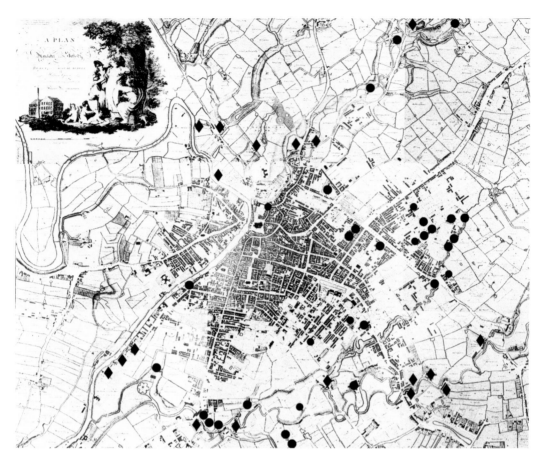

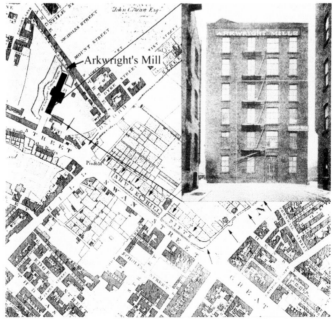

Above: The distribution of Manchester's textile mills and textile finishing works in 1800. Base map is Greene's survey of Manchester and Salford published in 1794. Dots indicate cotton-spinning factories and diamonds indicate finishing works.

Right: The location of Arkwright's cotton-spinning mill on Shudehill (shaded). Inset is a late nineteenth-century image of the southern gable of the mill.

Excavations in 2005 and 2014–15 showed Arkwright's Shudehill mill was 66 metres long, 9.1 metres wide, and five storeys high. The wooden floors were supported by a central row of cast-iron columns on each floor. There was an internal, centrally placed wheel pit. His attempt in 1781-82 to run the textile machinery directly using steam power generated by an atmospheric engine, manufactured by the London–based Thomas Hunt, proved unsuccessful. No archaeological evidence survived for this experimental set-up. Remains associated with the installation of the replacement returning engine installed in 1783 were found. This followed the same principle Arkwright employed at his Wirksworth Mill (though on a larger scale) where a steam engine pumped water from a well fed by a reservoir directly onto a waterwheel that ran the textile machinery. At Shudehill the remains of the beam wall and a well placed between the engine cylinder and the pump barrel, with contemporary accounts, suggested this new arrangement comprised a 30-inch (0.76-metre) steam cylinder and two, probably 20 inch (0.5 metre) pumps, which fed an 18-feet (5.48-metre) diameter waterwheel. The wheelpit was found to be largely intact during the excavations. The engine ran continuously, consuming 70cwt (3.56t) of coal per day. The chimney used to vent the waste gases from the adjacent boiler became a noted Manchester landmark in the 1780s (Miller and Glithero, 2016).

Several other first generation of steam-powered mills built in the 1790s have been excavated, including New Islington Mill and Salvin's Factory, both used hybrid steam- and water-power systems. Piccadilly Mill, built by the textile merchant Peter Drinkwater in 1789, was the first to install a Boulton and Watt rotary steam engine to run its machinery and by the early 1790s employed 500 people (Miller and Wild, 2007).

By 1800 at least nineteen textile mill sites in Manchester were using steam power to supplement or directly run cotton-spinning machinery. The high price of land meant these new steam-powered mills were built on the fringes of the growing town in two new industrial

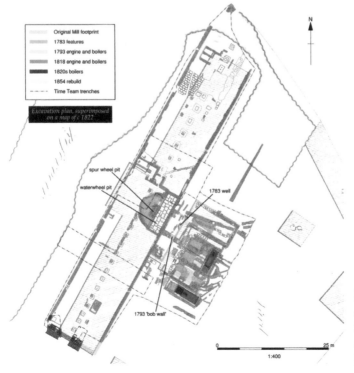

Excavation plan of Arkwright's mill from 2014. (Image courtesy of Oxford Archaeology North)

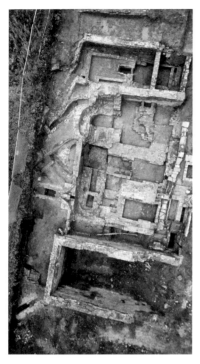

Above left: Aerial view of the excavated remains of the boiler and engine houses at Arkwright's mill. (Image courtesy of Oxford Archaeology North)

Above right: Arkwight's mill and chimney as shown on the frontispiece to Greene's map of Manchester, published in 1794.

suburbs: initially in Ancoats in the 1790s and from the 1800s in Chorlton-on-Medlock. The high technical capital cost was offset by building large multistorey manufacturing units using the latest technology to increase the rate of production to spin high value yarn products.

The only first generation of steam-powered cotton mill to survive as a standing structure in Manchester is Murrays' Mill, sited along the northern bank of the Rochdale Canal in Ancoats. Brothers Adam and George Murray were part of a wave of Scottish textile entrepreneurs who moved to Manchester in the 1780s and 1790s. Adam arrived in 1790 and by 1797 had premises on Henry Street, Newton Street and Union Street for manufacturing textile machinery and spinning cotton. In 1798 he formed a business partnership with his brother George to establish the Murrays Mill site, off Union Street in Ancoats (Miller & Wild, 2007). This complex was built in three phases between 1798 and 1806, eventually developing into one of the largest and most innovative mills in Manchester. The core of the complex was a quadrangle of blocks up to eight storeys high enclosing a canal basin linked by tunnel to the Rochdale Canal. The blocks had timber floors supported by cast-iron columns of cruciform cross-section, and the newly developed mule spinning machines were installed in the two largest blocks (Old Mill/Decker Mill and New Mill). These were powered by Boulton and Watt beam engines via centrally placed upright shafts.

The Old Mill/Decker Mill structure came to typify the Manchester cotton mill. It was a narrow, six-storey brick-built structure, located on the side of a canal and with, for the time,

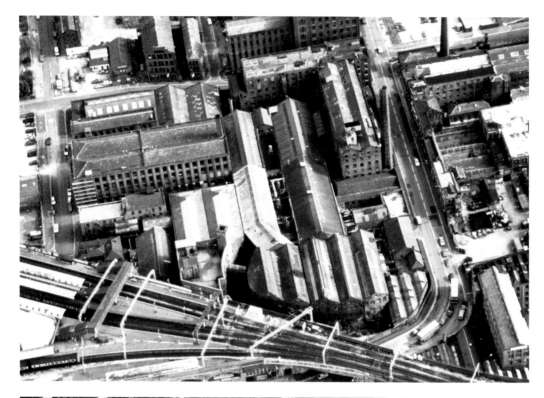

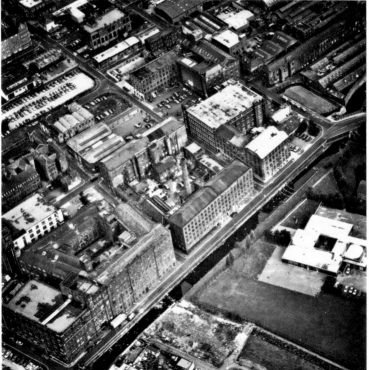

Above: Early nineteenth-century textile mills surviving in the Cambridge Street area of Manchester during the 1990s.

Left: McConnel and Murray's mills along the Rochdale Canal in Ancoats in the mid-1980s. (Image courtesy of Greater Manchester Archaeological Advisory Service)

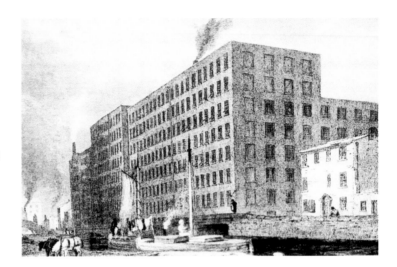

A. & G. Murray's mill as depicted around 1829 and published by G. Pyne in his *Lancashire Illustrated in a Series of Views* from 1831.

a large beam engine powering the spinning mules. In 1811 it was running 84,300 spindles (the standard unit for measuring the size of cotton-spinning mills). By 1815 the complex employed 1,215 mill hands, making it the largest single employer in the city and the largest single cotton mill complex in Britain (Miller and Wild, 2007).

The regular booms and busts of the cotton industry did not check the growth of the Manchester mill sector in the early nineteenth century. New mills continued to be established, increasing the manufacturing and commercial importance of the city. Among these was the spinning complex established by the Scottish textile manufacturers James McConnel and John Kennedy. Established immediately west of Murrays' mills in Ancoats in 1797, it saw steady expansion throughout the nineteenth century. The oldest surviving part of the complex is the Sedgwick Mill block, built in 1818–20. It was eight storeys high, seventeen bays long, and with an internal three-storey engine house of for a 54hp engine. By 1826 it had become the largest cotton mill complex in Manchester with 124,848 spindles, and in 1836 it was employing 1,590 mill hands (Little, 2009).

One of the best-preserved mills from the boom of the early to mid-1820s is Brownsfield Mill on the edge of Ancoats. Built in 1825–26, the mill lies on the south-western side of Great Ancoats Street, overlooking a private canal arm and the Brownsfield lock on the Rochdale Canal (Maw, Wyke & Kidd 2009). It was a steam-powered cotton-spinning factory built as a room-and-power mill by Nehemiah Gerrard and his son John, on land owned by John and Thomas Leech. The seven-storey southern wing was built around 1825 and had an internal engine house at the western gable. The northern six-storey wing was built shortly afterwards, and by 1831 was in use as a warehouse and manufacturing block. It had a non-fireproof structure with wooden floors supported by heavy pine beams, many of which retained their quality control marks showing they had been imported from the Baltic. Brownsfield Mill is notable for having the earliest surviving mill chimney-cum-stair tower in Manchester, for a highly unusual internal canal arm at the northern end of the northern wing, and for its covered courtyard. The power system remains are quite well preserved, with the engine house containing the original engine bed and evidence for two vertical drive shafts, one for each spinning block.

The scale of these new factories is captured in two comments from the early nineteenth century. The Swiss engineer Hans Caspar Escher noted 'in a single street in Manchester there are more spindles than in the whole of Switzerland' (Henderson 1968). Perhaps not surprising

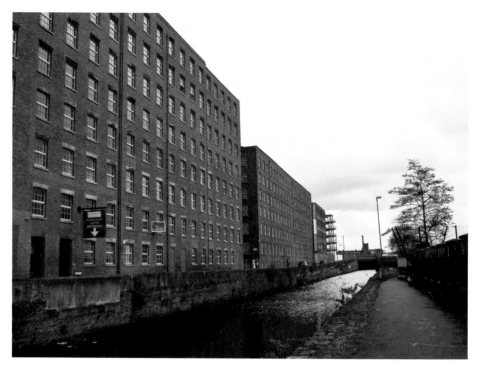

McConnel and Murray's mills on the Rochdale Canal in Ancoats in 2008.

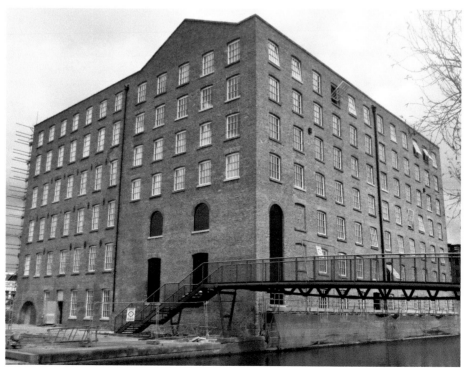

Brownfield Mill, built around 1825 as a room-and-power mill.

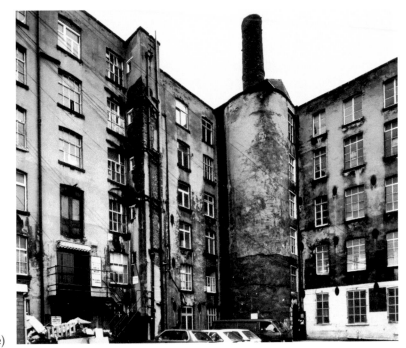

The courtyard at Brownfield Mill showing the combined circular stair tower and chimney. (Image courtesy of the Greater Manchester Advisory Service)

as in that year his home country had 151,000 spindles, which was 12 per cent fewer than the 169,300 contained in the two adjacent complexes of Murray's and McConnel's mills. The poet Robert Southey (1774–1843) was less complementary, noting that the textile factories in Manchester's two industrial suburbs were 'as large as convents without their antiquity, without their beauty, without their holiness; where you hear from within, as you pass along, the everlasting din of machinery' (Southey 1808). There was certainly nothing holy about the source of most of Manchester's raw cotton in the eighteenth and early nineteenth century: the north American cotton slave plantations.

CANALS

No less vital to Manchester's rapid growth during this period was the movement of raw materials and finished goods to and from this boom town. River navigations, canals and warehouses were as important as merchant houses, workshop dwellings and cotton mills in the success of Georgian Manchester. Manchester and Liverpool merchants sponsored the upgrading of the rivers Mersey and Irwell to make them navigable. The city's first purpose-built waterfront was opened on the banks of the Irwell in 1736 at the western end of Quay Street. This was the eastern end of the Mersey and Irwell Navigation Company, the port of Liverpool being the western start. Between 1759 and 1763 the city's first canal – indeed the first industrial arterial canal in the world – the Bridgewater, was built (Nevell 2013). This was a coal canal funded by the third Duke of Bridgewater to give better access for his mines at Worsley to the domestic coal market at Manchester. At its terminus in Manchester, the Castlefield Basin's prodigious engineering feats included the building of a clover leaf-shaped weir to control the flow of water of the River Medlock from the canal and the first mechanised transfer warehouse on the British canal system. It crossed a number of river

Detail of Manchester's river frontage with warehouses and Mersey flats along the riverbank at Parsonage, c. 1734.

An engraving of Manchester's first quay around 1740. This was opened by the Mersey & Irwell Navigation Company on Quay Street.

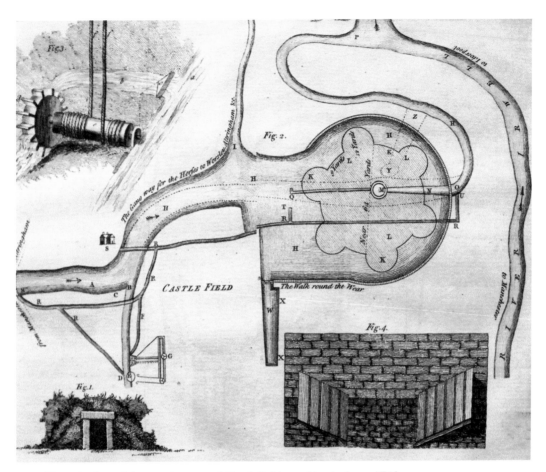

Young's plan of the newly opened Castlefield canal basin from 1769.

valleys, most spectacularly via the Barton aqueduct over the River Irwell (this was rebuilt as a swing bridge in the early 1890s). The Bridgewater Canal was extended to Runcorn on the Mersey Estuary in 1776, giving access to the London market.

The opening of the Castlefield canal basin in 1763 marked the emergence of the first dedicated warehouse district in Manchester. Around the basin six warehouses were erected between 1770 and 1840. Before 1770 warehouse facilities in the city were provided either by the dozens of coaching inns in the city or by private warehouses attached to one of the mercantile families, such as the Byroms' timber-framed early seveteenth-century premises in the Shambles (now the Wellington Inn). The Duke's and the Grocer's Warehouses, the first two canal warehouses to be erected at Castlefield in the1770s, represented a revolutionary new design. The Duke's was built for the Duke of Bridgewater as part of the canal's infrastructure and straddled the eastern end of the Castlefield canal basin where it met the River Medlock. The Grocer's Warehouse lay on the northern side of the basin, and terraced into the sandstone escarpment. Both buildings combined multiple storeys, split-level loading terracing into the riverside slopes, internal water-filled canal arms, and a hoist system run by water power. This meant canal barges could be moved under the building and goods loaded or unloaded directly (Nevell, 2013).

Grocers' Warehouse Layout

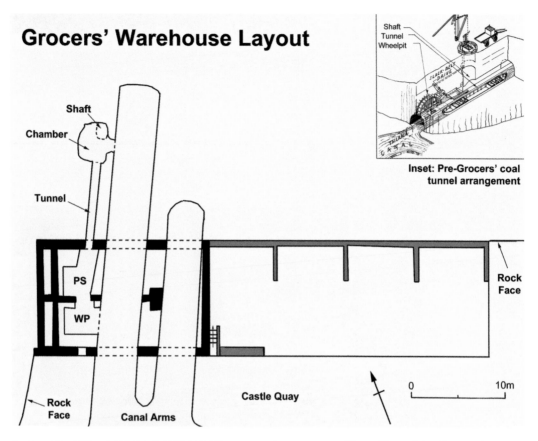

Inset: Pre-Grocers' coal tunnel arrangement

Above: Plan of the Grocers' Warehouse showing the canal arms and tunnels as well as its development.

Left: A reconstruction of the loading arrangements at the Grocers' Warehouse in the 1770s.

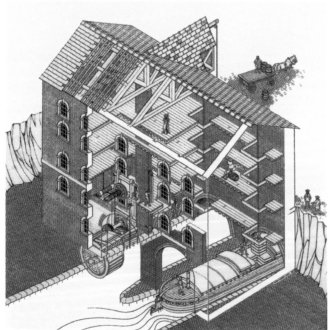

During the canal boom of the 1790s the Ashton and Rochdale Canals linked Manchester with the coal and textile districts to the east and north-east of the city, as well as providing a water transport link across the Pennines to West Yorkshire. Each of these had a canal basin on the eastern side of the town surrounded by warehouses, and were eventually linked to the Castlefield canal basin in 1804 by an extension of the Rochdale Canal (Maw, Wyke & Kidd, 2009). There were a series of private canal arms running off these canals, bring the total distance of canals in use in Manchester to over 8.5 km (5.5 miles). By the 1800s Manchester was the hub of a considerable canal system, which included not only the Bridgewater, Ashton and the Rochdale canals but also links to the wider network of 4,000 miles (6,000 km) of canals and river navigations developed in Britain before 1830.

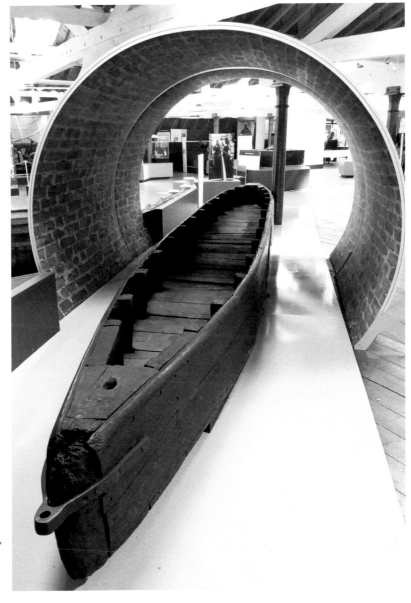

A surviving Bridgewater mine boat on display at the Boat Museum, Ellesmere Port, Cheshire.

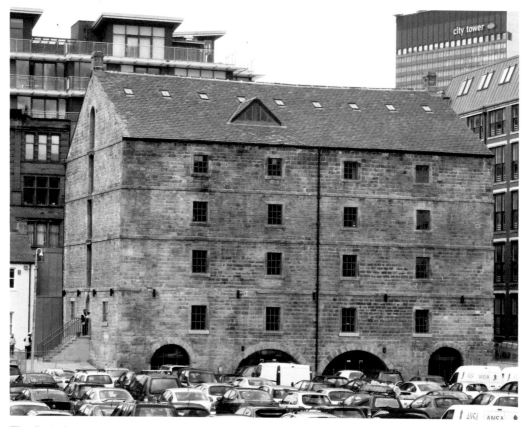

The Dale Street canal warehouse built by the Rochdale Canal company in 1806.

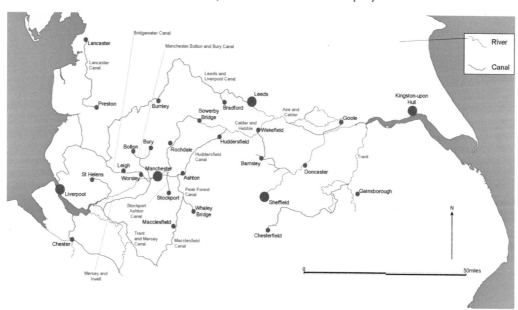

A plan of the canal system around Manchester and the southern Pennines in the 1820s.

VICTORIAN SHOCK CITY

The zenith of Manchester's economic and political power spanned the decades from the opening of the Liverpool to Manchester railway in 1830 to the peak of Lancashire cotton manufacturing output, just before the outbreak of the First World War in 1914. This long period of success, which coincided with Queen Victoria's reign (1837–1901), saw Manchester elect its first Members of Parliament since the 1650s, emerge as the transport hub of a suburban and intercity railway network, grow its expertise in engineering and machine tool manufacture, build an ocean-going canal, and rise to city status. It was a period of social change, with Manchester men and women helping to give birth to the co-operative and trades union movements, as well as promoting liberal economics, campaigning for the abolition of slavery, and for the improvement of working-class housing.

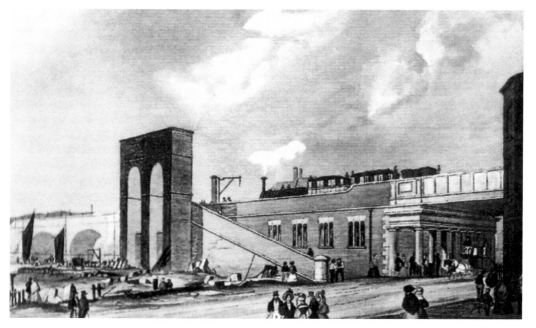

A view of the Liverpool & Manchester Railway buildings on Water Street in 1830.

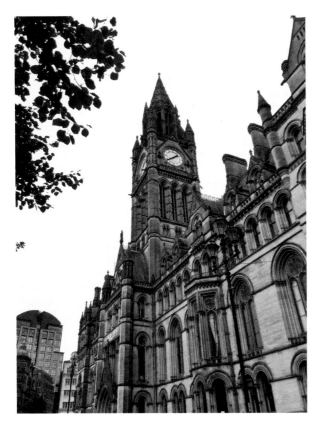

Manchester town hall, built in 1867–77 to a design by Alfred Waterhouse, was a symbol of the city's economic and political power in the mid-Victorian period.

FEEDING THE VICTORIAN CITY

Feeding the growing population of the new industrial city was as vital as moving raw materials in and finished goods out. Most urban tenants did not have yards or access to gardens to grow foodstuffs, and though some raised cattle and pigs in the backyards and courts of the city these were the exception. An extensive infrastructure was needed from transport, transhipment and distribution to point of sale to stop Manchester's population from starving. Three aspects of the Victorian need to provide foodstuffs can still be found in parts of the city: market halls, pubs and breweries.

One of the most visible and striking remains of the distribution of foodstuffs around the city centre are the market halls. The earliest site is Smithfield Market on High Street. This was established at the end of the eighteenth century. From 1846, once the nearby Oldham and Victoria stations had opened, was steadily expanded by the city on land especially purchased. The three-storey brick Market Offices of 1877 survives. Only the brick façades and cast-iron columns of the 1873 Wholesale Fish Market remain (their cast-iron and glass roofs long gone). A Wholesale Market Hall was built (1857–67) nearby on Goadsby Street. Its classical brick arched exterior and internal cast-iron columns and glazed roof still stands. Two other market hall survivals can be seen on the northern side of Liverpool Road in Castlefield. These are the cast-iron and glass structures of the Lower Campfield Market, built in 1876, and the Higher Campfield Market Hall, from 1878. Their presence emphasised the continuing importance of the Castlefield area as a transhipment hub for goods brought by road, rail and water (Hartwell, 2001).

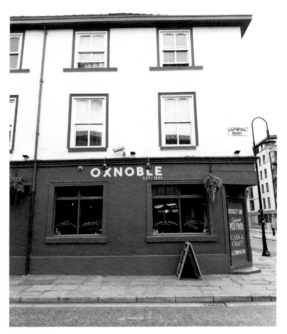

Right: Oxnoble public house on Liverpool Road. The name refers to a type of potato commonly imported into Manchester in the nineteenth century. Potato Wharf lies behind the pub.

Below: Part of the eastern façade of the Smithfield Fish Market on Shudehill.

The cast-iron-framed Higher Campfield Market, on Liverpool Road, built in 1878 to a design by Mangnall & Littlewood.

The brewing industry in the city developed rapidly in the mid-nineteenth century, with brewers taking advantage of new technology and legislation, and expanding into owning their own pubs, or tied houses as they became known. There remain some fine nineteenth- and early twentieth-century public houses across the city centre including the Briton's Protection, Peveril of the Peak and the City Arms.

Less visible are the brewing sites themselves. Three of the largest Victorian brewers were Boddingtons, Hydes and Holts. Boddington's brewery was established by Henry Boddington (1813–86) in 1853 when he took over the running of the Strangeways Brewery. This site was founded in 1778 by Thomas Caister and Thomas Fry. Boddington greatly expanded production and by 1877 was producing 100,000 barrels a year for over 100 tied pubs. The business became a limited company in 1883, by which date it was Manchester's largest brewer and one of the biggest such companies in northern England, its tall brick chimney becoming a local landmark for over a century.

Joseph Holt (1813–86) moved to Manchester and started working at the Strangeways Brewery in the early 1840s. He established his own brewing works in 1849 and in 1855 took over the Ducie Bridge brewery on Cheetham Hill Road, expanding by building a new brewery, the Derby Brewery on Empire Street off Cheetham Hill Road, in 1860. Later he bought dozens of local pubs through which to sell his beer. By 1900 the Joseph Holt Brewery was employing sixty people and brewing more than 40,000 barrels of beer annually. In 1901 the company opened a bottling plant. Two late nineteenth-century brick ranges and a three-storey brewing tower still survive in use on the site.

Hydes brewery was established in 1863 by the brothers Alfred and Ralph. In 1899 the business bought the Queens Brewery on Moss Lane in Moss Side, which by this date controlled dozens of tied pubs. The business was run by Annie Hyde from 1916 for fifty years. The Queens Brewery dates from 1861 when it was established by the Greatorex brothers. It still survives with its rectangular courtyard arrangement of two- and three-storey buildings, with the three-storey brewing tower to the rear.

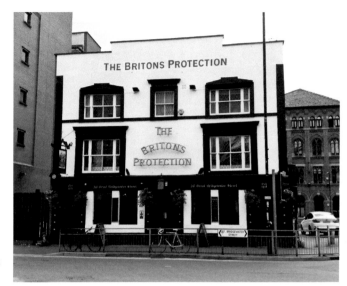

The Britons Protection
public house on Great
Bridgewater Street,
established in the early
nineteenth century.
The surviving interior dates
from the 1930s.

The nineteenth-century
City Arms and Vine public
houses on Kennedy Street.

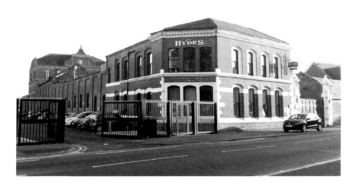

Holts Brewery, from the
1860s, on Moss Lane,
Mosside.

WAREHOUSING

The success of the manufacturing side of Manchester's textile economy in the first half of the nineteenth century was mirrored by the continuing growth of its commercial sector. The physical expression of this was the city's warehouses. These were notable for two reasons: the way in which they came to dominate various parts of the city and the development of the goods handling and marketing process. Typically, they serviced the textile industry, and emerged in large numbers from the 1840s, with examples being built as late as the 1920s.

By 1850 a large textile warehouse district had developed on the southern side of the city along Princess Street and the Rochdale Canal, with further warehouse areas between Water Street and Liverpool Road station and between the Ashton and Rochdale canal basins and Piccadilly station. Despite the importance, architecturally and archaeologically, of the canal and railway warehouse structures (McNeil, 2004; Nevell, 2003, 2013), it was the commercial warehouse, where grey cloth was continually delivered to the rear yards of these buildings, that came to typify Manchester's role as a warehouse centre, and large parts of the city centre remain dominated by dozens of these buildings (Taylor, Cooper & Barnwell, 2002). So emblematic did these commercial warehouses become of the city's commercial and industrial prowess, with their multiple roles as advertising symbol, statement of industrial power and prestige, and practical storage facility, that they became known simply as the Manchester Warehouse.

These warehouses, which could be as large as a cotton-spinning mill complex, were divided into three main types: home trade warehouses, overseas warehouses and multiple occupancy warehouses. Home trade and overseas warehouses, which can be found all over the textile warehouse district, were the most elaborately decorated (Hartwell, Hyde & Pevnser, 2004). Each floor was divided into departments that specialized in particular types of goods, overseen by a foreman who directed assistants and salesmen. The lightest goods were stored on the upper floors and the heavier goods on the lowest floors. These sales floors were used as sample and pattern rooms with benches for cloth examination, which required plenty of light, hence the many windows. In the basement of each warehouse was the packing floor with boilers, presses, later on hydraulic gear, and other services such as inspection and making-up;

The 1840s Victoria and Albert riverside warehouses seen from the River Irwell.

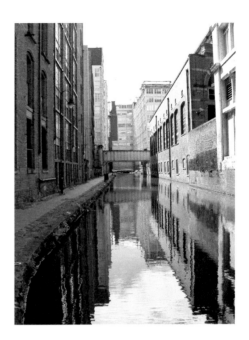

The Rochdale Canal looking west towards Oxford Street with nineteenth-century warehouses to the left and the Bloom Street power station to the right.

orders were lowered to the packing floor via hoists. Opposite the main entrance was often a grand staircase that penetrated the full height of the building to impress prospective buyers (Taylor, Cooper & Barnwell, 2002). Among the many fine mid-nineteenth-century examples in the city are No. 36 Charlotte Street, a palazzo-style warehouse designed by Edward Walters, which built in 1855–60, and S. & J. Watt's warehouse on Portland Street, now the Britannia hotel, which was built in 1855–58 using a different architectural style on each floor.

Multiple occupancy warehouses, a feature of Manchester's commercial quarter since the early nineteenth century, continued to be popular. Such structures were owned by a company to provide storage, display, office, and packing space, which were rented to a number of smaller companies, rather on the lines of the room-and-power mills of the early nineteenth century. They were used by companies involved both in the home and overseas markets. One of the finest surviving examples is Canada House on Chepstow Street. Built in 1909, this is a six-storey, ten-bay structure with wide windows in a terracotta façade, while the rear elevation is a glazed screen with octagonal piers rising to the full height of the building. Inside, every floor had its own offices, which were reached by a grand central staircase (Hartwell, Hyde & Pevsner, 2004).

In 1894 Manchester city council opened its hydraulic power system to be used by the basement presses that packed cotton bales and the lifts and cranes that could be found in the hundreds of textile warehouses. Hydraulic power was produced by water under high pressure and was developed in the mid-nineteenth century for turning wheels and lifting weights. Later it helped move railway wagons and was even used to wind the town hall clock. In 1895 the system had 19.1 km (12 miles) of hydraulic pipes beneath the city streets. It had a power station at Whitworth Street, with a second opened at Pitt Street in 1899 and a third on Water Street in 1909. The steam pumps were converted to electric drive in the 1920s. The network provided power to 247 machines. By 1935 this had grown to over 56.3 km (35 miles) of pipes servicing over 2,400 machines. The decline of the wholesale cotton industry in the 1960s led to its closure in 1972.

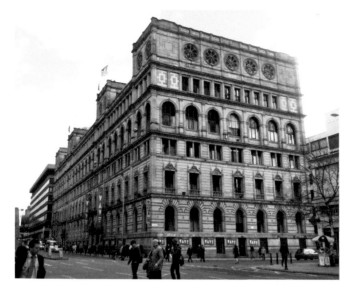

Watts' textile warehouse, now the Britannia Hotel, on Portland Street, built in 1851–56 to a design by Travis & Mangnall for James Watt, a drapery merchant.

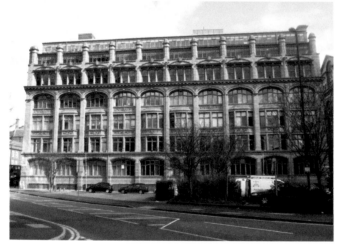

Canada House on Chepstow Street, a textile warehouse of 1909 designed by W. & G. Higginbottom.

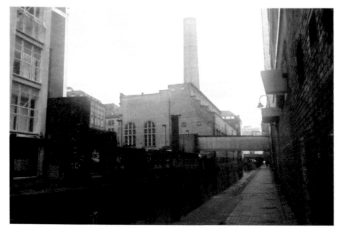

The Bloom Street power station on the Rochdale Canal.

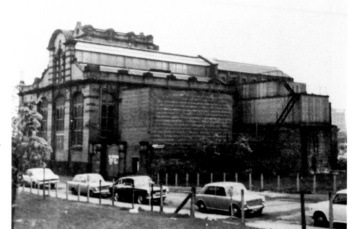

The exterior of the Water Street Hydraulic power station in the 1970s. (© Manchester Region Industrial Archaeology Society)

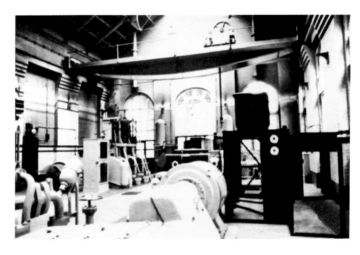

The interior of the Whitworth Street Hydraulic power station in the 1970s. (© Manchester Region Industrial Archaeology Society)

ENGINEERING

Manchester became a leading centre for machine tool, textile machinery and locomotive manufacture during the nineteenth century. The concentration of a large number of textile mills all needing engineering infrastructure in the form of line-shafting, boilers and steam engines. This encouraged the growth of iron founding and machine manufacture in the city from the 1790s onwards. The development of the city as a railway hub in the 1830s and 1840s cemented Manchester's position as an engineering centre of excellence, with the surrounding satellite cotton towns also developing their own engineering sectors and specialities.

Among the first generation of engineering firms were Peel & Williams (after 1825 Peel, Williams & Peel), engineers and millwrights. Founded by George Peel (1774–1810) and William Ward Williams (1772–1833) around 1800, they were initially iron founders, engineers and roller manufacturers producing steam engines and textile machinery. Their first factory was in Miller Street, though later factories were in Ancoats: the Phoenix Foundry was established around 1804 on Swan Street and the Soho Foundry of around 1810 lay on Pollard Street. Gas equipment and gear wheels became two of their early specialities, and later as Peel,

Left: Peel & Williams' Ancoats engineering works in the 1970s. Note the locomotive wheel on the pedimented gable. (© Manchester Region Industrial Archaeology Society)

Below: An engraving of Peel & Williams' Soho Foundry in Ancoats on the Ashton Canal in 1814.

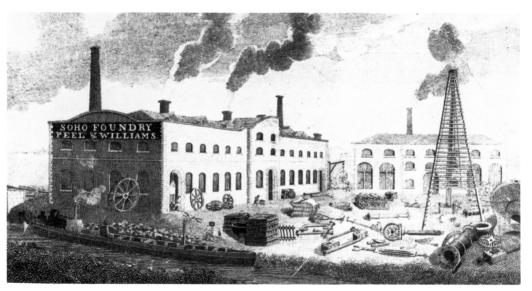

Williams & Peel they built stationary steam engines and boilers for many Lancashire textile mills. Later products included marine engines, locomotives and hydraulic presses, the latter becoming a significant feature (Musson, 1960).

Another very significant first-generation Manchester firm was Galloway, Bowman and Glasgow. William Galloway Snr (1768–1836) was a Scottish engineer who moved from London to Manchester in 1806, teaming up with James Bowman. The new firm worked from the Caledonian Foundry in Great Bridgewater Street as millwrights and engineers. The company became known for its boilers and mill engines, though it built several steam

locomotives for the Liverpool & Manchester Railway in 1831. It was taken over in 1839 by William and John Galloway, sons of William Snr, who had left the earlier partnership in 1835 to found the Knott Mill Ironworks. They continued to specialise in stationary steam engines and boilers, and became at one stage the largest manufacturer of steam boilers in the world. They built the last new reciprocating steam engine for a mill, of uniflow design, installed in 1926 at Elm Street Mill in Burnley. W. & J. Galloway was taken over by the Bolton engineering firm of Hick, Hargreaves & Co. in 1933.

By 1850 there were more than 100 iron founders and engineering firms based in Manchester. Among this second generation, three engineers stand out as pushing forward Manchester's reputation for engineering excellence and developing the discipline nationally.

William Fairbairn (1789–1874) was a Scottish structural engineer and shipbuilder who was based in Manchester for much of his career. He moved to the city in 1813 to work for Adam Parkinson and Thomas Hewes. In 1817, he launched his mill machinery business with James Lillie as 'Fairbairn and Lillie Engine Makers'. His Canal Street works in Ancoats made boilers, bridges, cast-iron framing, gearing, locomotives and ships. Fairbairn was best known for his innovative textile mill designs. In the 1820s and 1830s, he and the scientist Eaton Hodgkinson conducted a search for an optimal cross section for iron beams. Using their new knowledge they designed the bridge over Water Street for the Liverpool & Manchester Railway, which opened in 1830. Fairbairn and Lillie built the iron paddle steamer *Lord Dundas* at Manchester in 1830. The difficulties that were encountered in the construction of iron ships in an inland town like Manchester led to the removal of this branch of the business to Millwall, London, in 1834–35. Fairbairn also developed the high-pressure Lancashire boiler in 1844, and invented a riveting machine that greatly improved the quality and safety of boiler manufacture. In 1861, at the request of the UK Parliament, he conducted early research into metal fatigue, raising and lowering a 3 ton mass onto a wrought-iron cylinder 3,000,000 times before it fractured and showing a static load of 12 ton was needed for such an effect (Byrom, 2017).

Richard Roberts (1789–1864) was one of the city's first mechanical engineers. He established his Manchester business in 1816. Most famous for perfecting the self-acting mule spinning machine in 1830, which came to dominate cotton spinning in the Lancashire industry, he also designed machine tools and built steam locomotives with Sharp, his financial backer

Galloways Knott Mill ironworks in the 1970s. (© Manchester Region Industrial Archaeology Society)

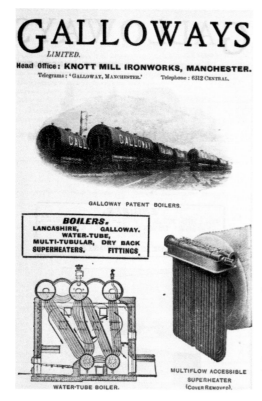

Left: An advert for Galloways boilers from Worrall's 'Cotton Spinners and Manufacturers' Directory for Lancashire' in 1918.

Below: Fairbairn's Ancoats engineering works in the 1970s. (© Manchester Region Industrial Archaeology Society)

The 1830 Water Street railway bridge shortly before its demolition in 1904. This was manufactured by William Fairbairn at his engineering works in Ancoats. (Image courtesy of Chetham's Library)

until 1843. The first Sharp-Roberts locomotive, the *Experiment*, was built for the Liverpool & Manchester Railway. In 1835 he developed a slotting machine to cut grooves or keyways into metal wheels and helped to improve the Lancashire loom (Hills, 2002).

The Stockport-born engineer Joseph Whitworth (1803–87) set up his first workshop in the city in 1833. His factory in Openshaw made many different types of machine, from gear cutters to metal planers or scrapers. In 1840 he developed a screw thread that became the British standard. Until then each engineering manufacturer used different thread types meaning that parts from machines were not interchangeable. In 1842 he developed a planing machine having realising that planing the metal surface rather than grinding it was the key to a truly flat surface. He also patented a micrometre for highly accurate measurements. At the Great Exhibition of 1851 Whitworth won more medals than any other engineer. In later life he founded the Whitworth Scholarship (1868) for advancing mechanical engineering and backed the new Manchester Mechanics' Institute. After his death, much of his fortune was left to the people of Manchester, his legacy funding the foundation of the Whitworth Institute and Park (now the Whitworth Art Gallery) and the building of the Whitworth Hall at Manchester University.

Clayton, Gorton and Openshaw, on the eastern side of Manchester, became the engineering and coal mining heart of the Victorian city. Access to the area was enabled by the completion of the Ashton Canal in 1797 through Bradford and Clayton and the building of the Ashton New Road turnpike in 1825. Further improvements came with the opening of what became the Manchester, Sheffield & Lincolnshire Railway through Ardwick, Gorton, and Openshaw in 1845. This new transport network encouraged the exploitation of the local coal seams in this part of the Lancashire coalfield and the setting up of dozens of engineering companies (Miller, 2013). These included many ironworks.

In 1848 the Gorton Carriage Company was established on Ashton Old Road, with access to the railway and the canal. It initially operated as a repair shop for locomotives and rolling stock for the Manchester, Sheffield & Lincolnshire Railway. In 1854 the locomotive superintendent Richard Peacock left to establish his own works, setting up with Charles Beyer opposite his old employers. This became the Gorton Foundry of Beyer Peacock & Co., who would become a world-famous name in locomotive production. By the time the works closed in 1966 it had built almost 8,000 locomotives.

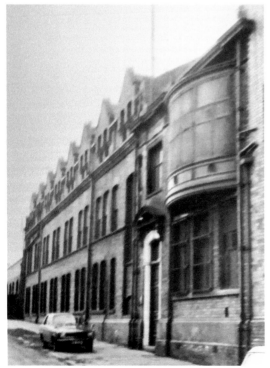

Above: Manufacturer's plaque for J. Whitworth & Co. on a lathe.

Left: The Whitworth engineering works in the 1970s. (© Manchester Region Industrial Archaeology Society)

Right: The interior of the Beyer Peacock engineering works in the 1970s.
(© Manchester Region Industrial Archaeology Society)

Below: A Fairbairn locomotive from 1838.

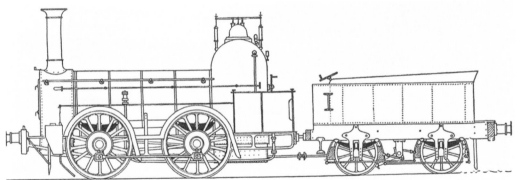

Other engineering firms in the area included George Saxon, who established an ironworks in 1854 specialising in mill engines, and Richard Johnson & Brother, wire manufacturers of Lewes Street in Ancoats, who established the Bradford Ironworks. In 1864 the firm introduced a continuous process for rolling galvanised wire (covered with zinc). By 1882 the Bradford works was producing 300 tons of telegraph cable a week (Miller, 2011).

Another firm set up to service the railways was the Ashbury Railway Carriage and Iron Company Ltd. This was originally founded in 1837 by John Ashbury (1806–66) on Commercial Street in Deansgate in the engineering quarter that grew up around Knott Mill. As with many early engineers in order to expand sites had to be found elsewhere in Manchester. After

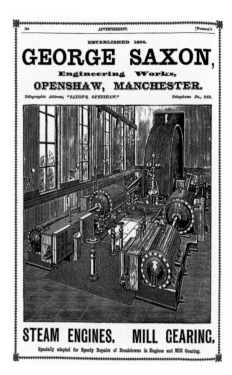

Left: Advert for George Saxon's stationary steam engines, from Worrall's 'Cotton Spinners and Manufacturers' Directory for Lancashire', 1891.

Below: Aerial view of the excavation of the Bradford ironworks in the shadow of the Commonwealth games stadium (now the Etihad football stadium). (© www.SuaveAirPhotos.co.uk)

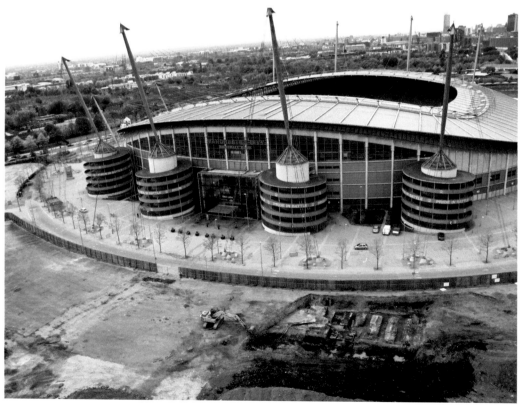

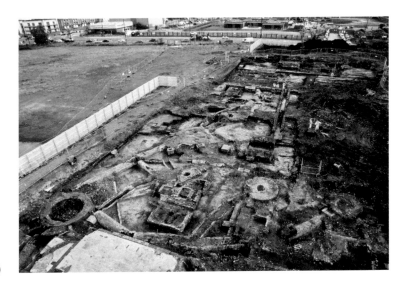

Aerial view of the excavations at Ashbury's carriage works in Openshaw. (Image courtesy of the Greater Manchester archaeological Advisory Service)

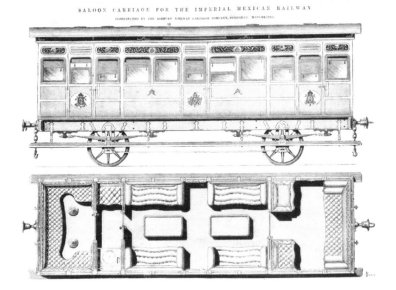

A saloon carriage built at Ashbury's carriage works, which was built for the Imperial Mexican Railway in 1867.

moving to Ardwick in 1844 a site in Openshaw was developed from 1847 and by 1860 was employing 1,700 people, making it one of the larger engineering employers in the city. The firm specialised in producing railway rolling stock, locomotive components and wagon repairs for the Manchester, Sheffield & Lincolnshire Railway. Like many other engineering works in the early 1830s, they also built several locomotives for the Liverpool & Manchester Railway. They supplied 6,000 wagons for the building of the Manchester Ship Canal in the later 1880s and early 1890s, being able to produce 100 wagons and ten railways carriages per week at this time. Taken over in 1919 the site was closed in 1928. Part of the 6.7 ha works was excavated in 2012 and 2014, revealing the extensive remains of flues and chimneys as well as the bases of cupola furnaces, an open hearth for making steel and the foundations of a travelling crane that were used to make parts for the carriages and wagons (Hayes, 2014).

COAL MINING, BRICK MAKING AND GLASSMAKING

Among the many other smaller-scale industries to be found in nineteenth-century Manchester, three have seen extensive archaeological investigation: brick making, coal mining and glassmaking.

The most common building material from the eighteenth to the early twentieth century was brick and most of the city's supplies were produced locally. Green's 1794 map of Manchester and Salford shows the two industrial towns ringed by brickworks, which made use of the extensive clays around Manchester. An early nineteenth-century brick clamp kiln was excavated on Oxford Street, south of the city centre in 2015. This was the simplest form of kiln available, with the air-dried bricks stacked in a roughly square pile, possibly as high as 10 metres and then fired for several days. The burnt ground surface striped with the black fire channels was found to survive beneath 1840s workers' housing. A more sophisticated fire-brickworks was investigated at Clayton in 2010–12. Here, around 1850, Robert Williams established a brickworks amid the chemical works off Ashton New Road in Clayton. R. Williams & Co. produced refractory brick capable of withstanding and containing intense heat. The manufacturing process involved hand making up to 3,000 bricks a day, which were dried before being fired in circular kilns in temperatures ranging from 1,310 to 1,800 degrees Celsius, depending on the final product. The company also produced other products such as chimney tops, drain pipes and 'sanitary' wares. The archaeologists found the remains of the drying shed and a processing shed during the investigations.

A Hoffman-type continuous kiln was revealed at Bradford in 2010 (Miller, 2011; Miller, 2013). Established by Bradford Colliery, it was used to make tiles and bricks. This type of kiln was kept working continuously, and was ideal for producing large volumes of products. It comprised a central barrel arch, creating a circuit around the interior of the kiln and forming a passage for the fire. A series of chambers connected the fire passages and were separated from each other by a temporary wall of combustible material. Pallets of bricks were stacked in each chamber, and the chambers fired in turn, the hot gases being reused in neighbouring chambers. The Bradford Colliery example was 30 metres long and 17 metres wide with twelve or fourteen chambers.

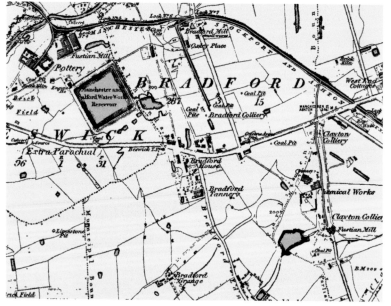

Brickworks (underlined in red) as shown on the Ordnance Survey 6-inch map covering the Bradford and Clayton districts of Manchester (Lancashire series, sheet 105, 1848–49).

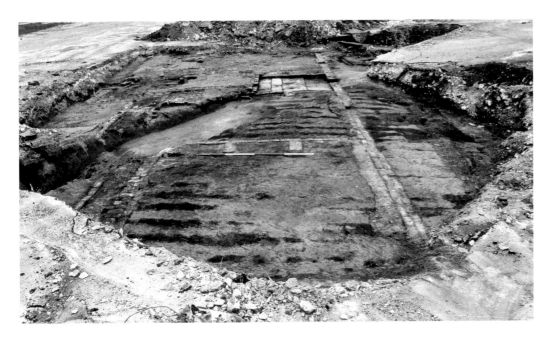

Above: An early
nineteenth-century
clamp kiln found
beneath the
foundations of later
workers' housing on
Oxford Road. (Image
courtesy of the
Greater Manchester
Archaeological
Advisory Service)

Right: Plan and
section through
a brick kiln of
the type used by
R. Williams & Co.

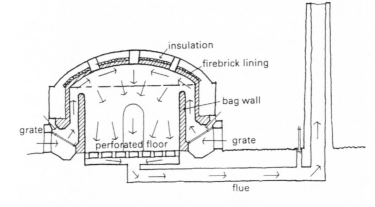

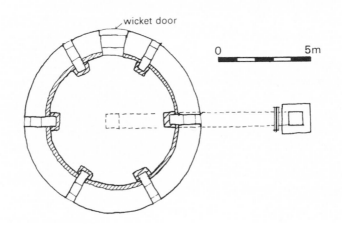

R. WILLIAMS & CO.,

MANUFACTURERS OF

FIRE BRICKS,

Chimney Tops, Sanitary Draining Pipes, &c.

ASHTON NEW ROAD, BRADFORD,

MANCHESTER.

Trade directory advert for the Manchester brick makers R. Williams & Co., 1863.

The bricks produced were stamped with the letters 'BC'. Both the Bradford Colliery Brickworks and works of Williams & Co. closed around 1903.

These two brick kiln works were associated with the local coal industry. Coal had been hand dug in east Manchester from at least the seventeenth century. The opening of the Ashton Canal in 1797 through the area enabled coal to be transported in large volumes quickly to the Manchester market. Two of the largest nineteenth-century collieries were Bradford and Clayton.

Bradford Colliery lay in the Bradford district of east Manchester and was linked to the Ashton Canal by its own private arm, and later to the railway network. One of the longest-lived collieries in the wider city region, it was established sometime during the 1830s by T. Porter esq. and sold to Messrs Clegg and Livesey in 1845 and traded as the Bradford Colliery Company. It was bought in 1899 by the Fine Cotton Spinners and Doublers Association as a way of securing cheap coal and cutting costs for their Manchester operations. Sold again in 1935 to Manchester Collieries Ltd, it was nationalised in 1948 and revamped with new concrete headstocks and Koepe winding gear. It finally closed in 1968. A shaft over 500 metres deep was dug in 1854, which required the latest steam winding technology to lift the coal and ventilate the mine. By the early twentieth century it was dominated by a pair of winding head gears servicing a new shaft more than 850 metres deep and employing around 500 miners. Remains of the large bank of Lancashire boilers needed to raise the steam and the adjacent engine house were excavated in 2010 (Miller, 2011).

Clayton Colliery was established around 1790 by John Thornely of the nearby Clayton Hall. A long private canal arm from the Ashton Canal provided the main transport route to Manchester. The colliery passed through several hands, finally coming into the sole ownership of the Bradbury family in the 1840s, when it was employing eighty men including ten boys under the age of thirteen. In the 1850s it was part of a group of collieries run by the family that included pits in Haughton and Hyde to the east. Clayton was closed in 1878 after a history of unsafe practices that saw regular underground explosions and loss of life, especially in the 1820s, 1850s, and 1860s (Miller, 2013).

The first Manchester glassworks was recorded in 1795, while the last site closed as late as 1964. The industry's heyday was around 1870 when seventeen sites were working. Over the century and half of its life around twenty-five flint glass work sites were operated by thirty-nine different businesses, totalling half the sites in Ancoats. The industry in the city was notable for its rapid expansion, in part resulting from the lifting of the Excise Tax on glasswares in 1845. Its equally rapid decline was due to the unregulated competition from overseas. Most of the prosperity of the Manchester industry was based upon the introduction of the glass press during the 1850s, led by Percival Vickers & Co., who gradually shifted their production from blown glass to pressed glass in the late nineteenth century (Nevell, 2008).

In 2003 three kilns were excavated at the Percival Vickers & Co. works in Jersey Street, Ancoats. The site was the largest glassworks in the city, working in the period 1844–1914. Although largely cleared, an office and warehouse structure survive on the site. In 1863 the works had 373 employees including forty-three boys who were less than thirteen years of age. Excavations revealed the remains of the two original glass cones from around 1844, each around 6.4 metres across with foundations for flues beneath the floor of the kiln 2 metres deep. Contemporary with these was the rectangular brick-built annealing house where the glass products were cooled in a controlled environment. A third kiln was added in the 1870s east of the others. This had an innovative design that allowed the combustion air to be pre-heated, while an automatic feeder provided the fuel, thereby reducing costs (Miller, 2007; Nevell, 2008).

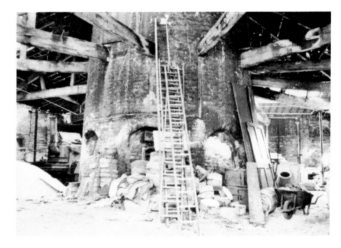

A glass kiln at Marsden's glassworks on Water Street, Manchester, in 1966. (© Manchester Region Industrial Archaeology Society)

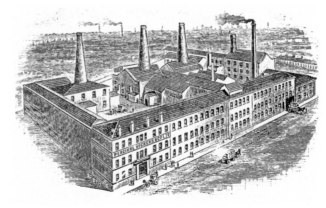

Engraving of the Percival Vickers glassworks from the company catalogue of 1902.

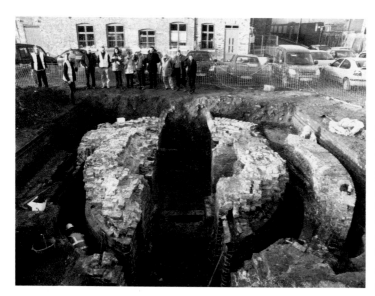

A late nineteenth-century glass kiln at the Percival Vickers glassworks on Jersey Street during excavation by Oxford Archaeology North. (Image courtesy of the Greater Manchester Archaeology Advisory Service)

MILLS

Cotton spinning remained the dominate employment within the city throughout the nineteenth century, even though its relative importance in Manchester's economic life declined. The last major textile mill building boom in Manchester occurred during the years 1848 to 1853 (Williams with Farnie, 1992). A total of 108 working cotton spinning and weaving mills are recorded in Manchester in 1853, with dozens more finishing sites within the boundaries of the modern city. Nearly all of the mills were cotton-spinning and weaving factories, although there was a silk-finishing mill on Hardman Street. Mills could be found all over the centre of Manchester, on Millgate in the heart of the old medieval town and on Bridge Street in the Georgian town by the Irwell, though most were distributed along the Ashton and Rochdale canals, beside private canal arms, and along the rivers Irk, Irwell and Medlock. After 1853 new mills within Manchester tended to be established in the suburbs around the city. The year 1853 represented the peak of the industry in terms of manufacturing sites within the city, though output did not reach its zenith, like the rest of the Lancashire cotton-spinning industry, until 1913 at 3,703,000 working spindles (Williams with Farnie, 1992).

Of the late period mills in the city, three stand out, both metaphorically and literally. The tall chimney of Victoria Mill, in Miles Platting, can still be seen from Ancoats and remains a prominent landmark on the eastern side of the city. The mill was built in two phases in 1869 and 1873 as an architect-designed structure by George Woodhouse for the firm of William Holland (Hartwell, Hyde & Pevsner, 2004). It has a U-shaped plan formed by two large six-storey cotton-spinning blocks linked by an engine house and a tall circular chimney that has a stair tower wrapped around the lower part. The overall appearance is Italianate, a popular design of the period, with red-brick dressings and corner pilasters. The central engine house was replaced in 1902 with an external engine house for a horizontal steam engine that ran a rope drive in a rope race, a system that was introduced into Lancashire mills from the 1870s. Many existing mills were extended in this period, such as Chorlton New Mills, which had a new wing and engine house built in the 1840s. Paragon and Royal Mills, both of six storeys

and nine bays, were built in 1912 as additional wings to the McConnel and Kennedy's Ancoats complex, and marked another major step in the development of the textile-spinning industry since both were built as electrically powered mills, which were supplied from Manchester's municipal grid. They were built of steel framing with concrete floors, had flat roofs, drive-shaft towers for the electrically driven transmission system, and architectural ornamentation such as red brick with terracotta banding and baroque detailing, typical of late period cotton-spinning mills (Hartwell, 2001).

One of the most important developments in the city's textile industry was the establishment of the Clayton Aniline factory in 1876 for manufacturing synthetic dyes. The first synthetic dye had been discovered, accidentally, by W. H. Perkins in 1856. By reacting aniline with potassium dichromate and then extracting the resultant compound by adding alcohol, a rich purple dye could be produced. This led to the development of a range of synthetic dyes, which proved extremely popular with calico printers, Lancashire having the largest concentration in Britain.

Above: The mills of Ancoats as sketched by K. F. Schinkel in 1826, showing on the left McConnel's mills and Murray's mills.

Right: The distribution (red dots) of working cotton-spinning, weaving and finishing mills in Manchester in 1850.

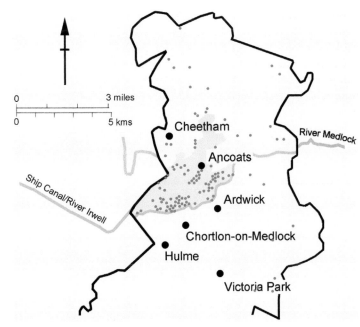

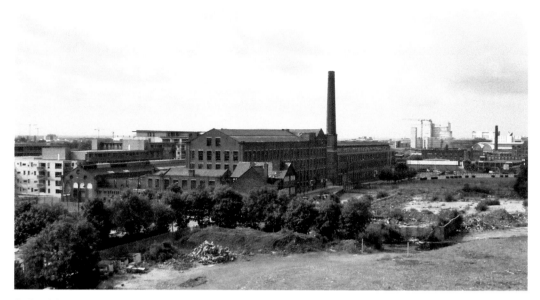

Pollard Street, Ancoats. Showing to the left of the chimney is the Vulcan Iron Works, and right is the narrower Cooperative Wholesale Society warehouse, around 2010. The site of the Soho engineering works lies in the foreground.

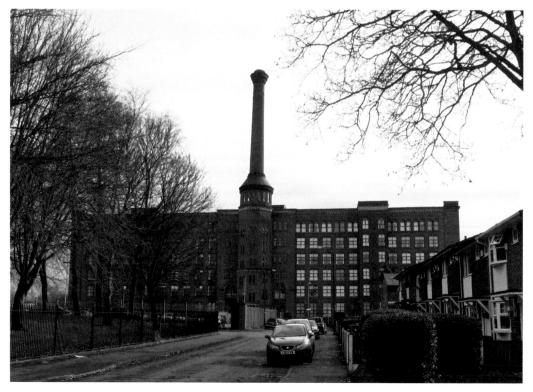

Victoria Double Mill, Lower Vickers Street, Miles Platting, built between 1869 and 1873 and designed by George Woodhouse. Its central chimney forms a prominent landmark.

Chorlton New Mills, Chorlton-upon-Medlock, built between 1813 and 1853, showing the 1845 link block incorporating a new engine house at the corner of Hulme Street and Cambridge Street.

The site of the Clayton Aniline chemical works during clearance. (© www. SuaveAirPhotos.co.uk)

Clayton Aniline was founded by the Frenchman Dr Charles Dreyfuss on land adjacent to the Ashton Canal. The original works comprised two ranges of buildings between the canal (naptha shed, Mirbane shed and nitric cake shed) and Chatham Street (aniline salts store, boiler house, offices, stables and smithy), with aniline being manufactured in a building in the centre of the site. Nitric acid was manufactured at the western end of the site. Excavation in 2011 revealed the remains of the boiler house and its chimney, the aniline salts shed and smithy (Miller, 2013).

The most significant development in the Manchester cotton industry came with the way it was structured. The Fine Cotton Spinners and Doublers Association was founded in 1898. This was an amalgamation of several large Manchester cotton-spinning firms specialising in Sea Island Cottons and was a response to growing overseas competition. The founders were the Manchester textile firms of James and Wainwright Bellhouse, C. E. Bennett & Co., Thomas Houldsworth & Co., McConnel & Co., and A. & G. Murray, though other Lancashire firms followed. The new combine ran sixty mills and employed over 30,000 mill hands, and for thirty years was the world's largest cotton-spinning company.

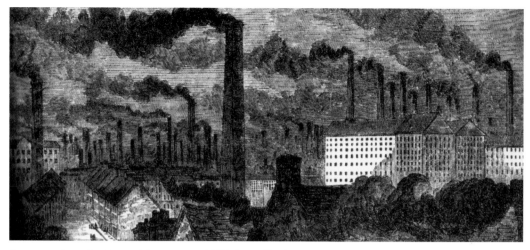

An engraving of industrial Ancoats in 1853 from *The Builder* magazine.

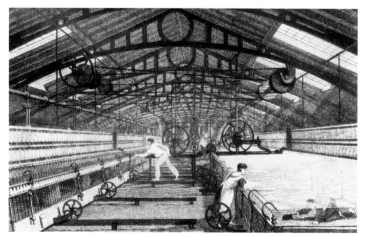

An engraving of automatic textile mule spinning in a Manchester cotton mill from 1830.

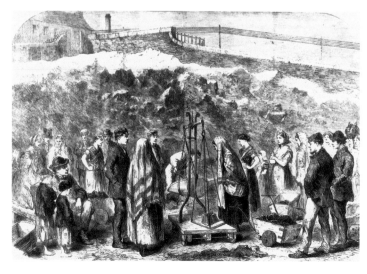

Unemployed operatives collecting their coal allowance at the coal wharf in Castlefield during the Cotton Famine in 1862. (Image from *Illustrated London News*)

One aspect of the Manchester cotton industry that is frequently overlooked is its links to the slave industry. Despite the abolition of the slave trade in 1807 and of slavery within the British Empire in 1833, during the mid-nineteenth century the majority of the cheap cotton imported into Lancashire was still slave grown. As late as the 1850s some three-quarters of all Lancashire cotton was supplied by the slave states of the American south. That said, Manchester played an increasingly active part in the anti-slavery movement. After the passing of the Abolition Act in 1833, local abolitionists reacted to the disappointment that slavery was being continued by clandestine means in British colonies. Meetings were organised, protests made and petitions raised in the city. This campaigning might have had little effect on Manchester's textile manufacturers had it not been for the American Civil War of 1861–65. The economic blockade of the southern states led to a shortage of raw cotton. This was partly offset by overproduction in Lancashire's mills and stockpiling by Lancashire merchants in the few years before 1861. Nevertheless, from 1862 many Lancashire mills were closed due to the shortages, and the rising unemployment of textile workers and the poverty that resulted led to what was called the Cotton Famine. Although supplies of American cotton quickly returned after the end of the war in 1865, the economic shock and the reliance of the Lancashire cotton industry on one main source forced Manchester and Lancashire cotton manufacturers to diversify their supplies of raw cotton. The role of the Lancashire cotton hands in opposing slavery was acknowledged in an open letter written by the President of the United States, Abraham Lincoln, to Manchester workers in January 1863 (Kidd & Wyke, 2016).

TRANSPORT

The commercial and manufacturing sectors of the Manchester economy depended upon its role as the most important transport hub in the region and the network of transport links across the city. Many of the new collieries, engineering works and mills of the nineteenth century had direct access to the canal system through a series of private canal arms that could be found from Hulme in the west to Bradford in the east (Maw, Wyke & Kidd, 2009). They were a major factor in enabling the new industrial city to expand without choking its supply lines for raw materials.

Manchester maintained its role as a transport hub throughout the development of the railways in the nineteenth century. It was the eastern terminus of the Liverpool & Manchester Railway, opened in 1830 as the world's first intercity passenger line. From its inception this engineering project was viewed as a momentous achievement in transport history. Stephenson's arched stone bridge over the River Irwell, which bares his initials, was in regular use up to opening of the Ordsall Chord railway link in 2017. The Liverpool Road terminus' life as a passenger station was short, being superseded by Victoria station in 1844, but it continued as a goods depot until it closed in September 1975, with the key buildings of the 1830s still intact (McNeil, 2004).

The city saw the opening of the first commuter railway in 1849 – the Manchester South Junction & Altrincham Railway. By that year there were three lines over the Pennines from the city: the Manchester and Leeds through Rochdale, the London & North Western line to Huddersfield via Ashton-under-Lyne, and the Manchester, Sheffield & Lincolnshire via Ashton and Glossop. Embankments, cuttings, tunnels and viaducts were used to deal with the geographical features of a particular route. One consequence of railway competition was the development of a series of railway termini around the city. After Liverpool Road opened in 1830, the Oldham Road railway station was opened by the Manchester & Leeds Railway in 1839, though converted

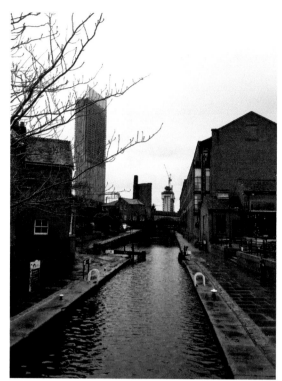

Left: Lock No. 92 on the Rochdale Canal, looking eastwards from the Castlefield canal basin towards Deansgate.

Below: The façade of the 1830 departure station at the Liverpool Road railway station.

Stephenson's Irwell railway bridge for the Liverpool & Manchester Railway during renovation works in 2017.

The 1830 warehouse at Liverpool Road station.

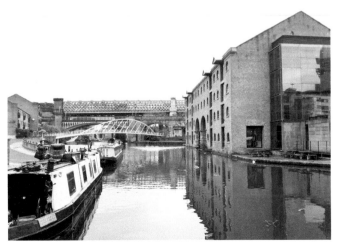

The Castelfield canal basin with the 1825 merchant's warehouse to the right and beyond two of the railway viaducts that cross the transport hub.

to just goods traffic in 1844 after the line was extended to the nearby Victoria station. Piccadilly station was opened in 1842 as a joint station for the Manchester & Birmingham Railway (later the London & North Western Railway) and the Sheffield, Ashton-under-Lyne & Manchester Railway (later the Manchester, Sheffield & Lincolnshire Railway). Victoria station opened in 1844 as a joint station for the Liverpool & Manchester Railway and the Manchester & Leeds Railway. Manchester's fifth terminal station was Central station, opened in 1880 by the Cheshire Lines Committee on Windmill Street. The huge wrought-iron and glass arched train shed has a width of 64 metres, just 9 metres less than St Pancras and is arguably the city's prettiest station building. The final terminal station building was the Great North Railway Warehouse complex at the southern end of Deansgate. This was opened in 1898.

The railway network ensured that Manchester's role as a commercial hub would be maintained into the twentieth century, through the construction of more warehousing and railway sidings around these railway termini.

The interior of the Oldham Street goods depot in 1965. (© Manchester Region Industrial Archaeology Society)

The interior of the train shed at Piccadilly station, showing part of the 1880–83 roof structure.

Part of the classical façade of Victoria station, built in 1909 to a design by William Dawes for the Lancashire & Yorkshire Railway.

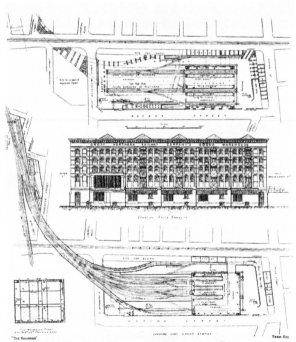

Plan of the Great Northern Railway's goods warehouse and transport hub on Deansgate, which opened in 1898.

LIVING IN THE VICTORIAN CITY

ndustrial housing (workshop dwellings, blind-backs, back-to-backs and through houses) was a necessary counterpart to the urban, steam-powered factory. Factory owners needed to be able to guarantee a regular supply of labour, in return for standardized wages and hours, and a new landless tenantry, in purpose-built urban houses, emerged in nineteenth-century Manchester to fulfil this need. The rapid rise in Manchester's population required huge amounts of housing, and between 1773 and 1821 the number of dwellings in the city rose from 3,446 to 17,257 (Kidd, 2002). By 1851 had reached nearly 50,000 houses (Nevell, 2011).

By the late twentieth century few physical remains of workers' housing from this period survived within the centre of Manchester. This was due to the concerted effort to remove slum housing by a succession of city administrations from the 1860s to the 1970s. Beyond the historic eighteenth-century centre of Manchester a series of working-class suburbs developed as the tenant population was pushed out of the old town. Ancoats and Chorlton-upon-Medlock developed to the east and south-east of the Georgian town during the 1790s and 1800s. Hulme, on the south-western side of the city south of Castlefield,

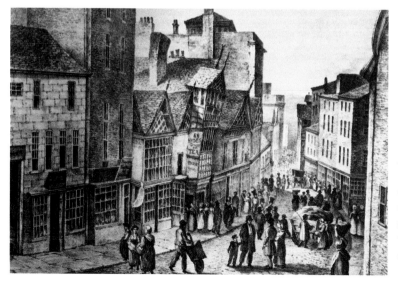

An early nineteenth-century engraving of the Georgian and timber-framed houses on Lower Market Street.

Right: Late eighteenth-century workshop dwellings, with their distinctive multi-light windows on the top floors, on Liverpool Road in Castlefield.

Below: Left, the main suburbs of nineteenth-century Manchester. Right, the police districts of central Victorian Manchester in 1832. (Reproduced with the permission of Terry Wyke)

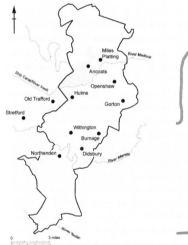

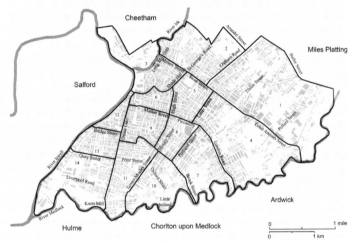

emerged in the 1800s and 1820s. By 1851 the working-class suburbs, characterised by row upon row of terraced houses, were wrapped around the commercial and manufacturing centre of the city from Hulme in the west, through Moss Side and Rusholme in the south, to Ardwick and Beswick in the east and Collyhurst in the north-east. Later nineteenth-century urban expansion would take place in Withington, Disbury and Fallowfield to the south, Openshaw, Gorton and Longsight to the east and Moston and Blackley to the north.

THE EMERGENCE OF SLUM HOUSING

One of several themes to emerge from the archaeological excavation of workers' housing in the city was the issue of housing quality and landownership (Nevell, 2008 & 2014). There is a marked decline in the quality of workers' housing between the late eighteenth century and the 1820s and 1830s, the latter decades being particularly notable for the poor build quality

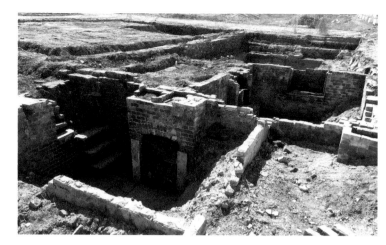

The excavation of mid-nineteenth-century cellar dwellings on Dantzic Street, Manchester, in 2015, by the University of Salford. (Image courtesy of the Greater Manchester Archaeological Advisory Service)

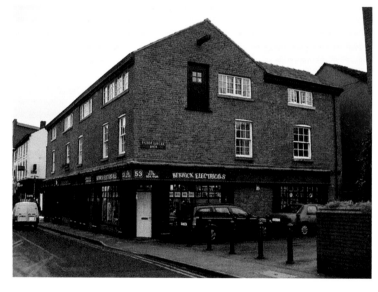

Workshop dwelling at Nos 49–53 Tib Street were built in the period between 1783 and 1794 and had shared attic and basement workshops.

and cramped conditions. This coincided with the rise of small-scale landowners and renters who speculated in building housing on tiny plots.

An example of the way in which overcrowded slum housing developed during this period is represented by the upstanding remains of Nos 69–77 Lever Street in the northern quarter. These began as a speculative development of five four-storey workshop-dwellings built progressively over a decade by a plasterer, William Bradley. The first phase spanned the period 1780–88 when a row of five houses was built. These had attic-floor workshops but the basements, ground and first floors appear to have been divided for tenement housing in all but one case. Each house had its own rear yard with an outside privy. The second phase saw two-storey extensions, lit separately, built into the rear yard areas by around 1790, and a third phase by 1794 saw one-up-one-down cottages added to the rear of these in turn, facing Bradley Street. By 1831 a five-bay, three-storey warehouse was built across two backyards. Access to the phase two and phase three housing was only from the Bradley Street side of the properties (Taylor and Holder, 2008). These properties encapsulate many of the features of

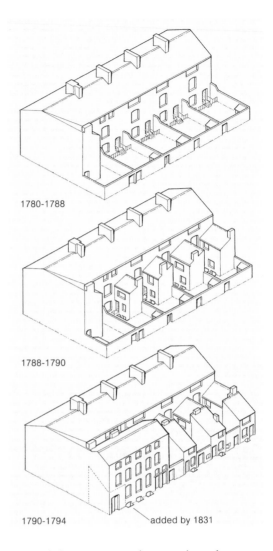

1780-1788

1788-1790

The development of the urban housing
at Bradley Street, Manchester, 1780–94.
(Image courtesy of Historic England)

1790-1794 added by 1831

later slum housing—small domestic unit size, poor lighting, restricted access through narrow alleyways and a lack of sanitation (Nevell, 2011).

The development of the industrial suburb of Ancoats demonstrates how even greenfield sites could become slum areas (Nevell, 2014). The starting point for the urban development of Ancoats is said to have been in 1775 when part of the Great Croft between Ancoats Lane and Newton Lane (the present Great Ancoats Street and Oldham Road) was sold to Thomas Boond [*sic*], a bricklayer, by George and Henry Cornwall Legh, members of the Cheshire gentry (Roberts, 1993). By the 1790s map evidence shows a gridiron of streets had been laid out between Great Ancoats Street and Oldham Road. Property not only lined those main thoroughfares but had also begun to be built in the streets behind. At this date development was densest in an area which lay closest to Great Ancoats Street and Oldham Road. Elsewhere building was more scattered, with some blocks of the gridiron still vacant. By 1801 there were 11,039 people, a seventh of Manchester's population, living in the new industrial suburb.

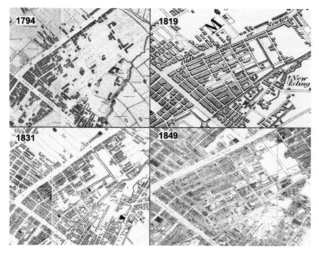

The urban development of northern Ancoats as recorded, clockwise from top left, on Green's map of Manchester published in 1794; Johnson's map of Manchester, published in 1819; Banck's map, published in 1831; and the Ordnance Survey 60-inch survey of Manchester, sheet 24, published in 1849.

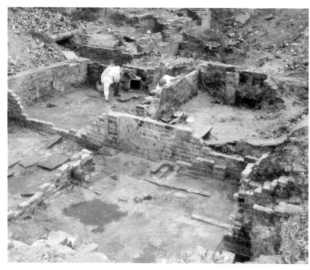

The excavation of cellars of early nineteenth-century workers' housing at Piccadilly Place by Oxford Archaeology North in 2005.

During the early nineteenth century the industrialisation of Ancoats continued unabated, with glassworks and engineering companies joining the textile mills, and this process attracted workers from both the rural hinterland of Lancashire and from areas further afield, notably Ireland. By 1851 nearly every piece of land in Ancoats had been built upon and in that year its population numbered 55,983 (Nevell, 2008). The 1849–50 large-scale Ordnance Survey map for Ancoats shows a large number of cellar dwellings, back-to-back houses and court housing in among the mills of the area. For contemporary observers Ancoats' urbanisation was dramatic even by Manchester's standards, as were the consequences in terms of living conditions. In the early 1840s Frederick Engels visited Ancoats as part of his investigation into the conditions of the working classes in Britain. During this visit he considered the construction of the workers' houses in the area around Jersey Street and commented that 'on closer examination, it becomes evident that the walls of these cottages are as thin as it is possible to make them. The outer walls, those of the cellar, which bear the weight of the ground-floor and roof, are one whole brick thick at most' (Engels, 1845).

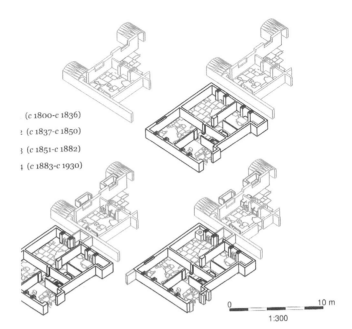

(c 1800-c 1836)

2 (c 1837-c 1850)

3 (c 1851-c 1882)

4 (c 1883-c 1930)

0 10 m

1:300

The development of the domestic cellars excavated at Piccadilly Place. (Image courtesy of Oxford Archaeology North)

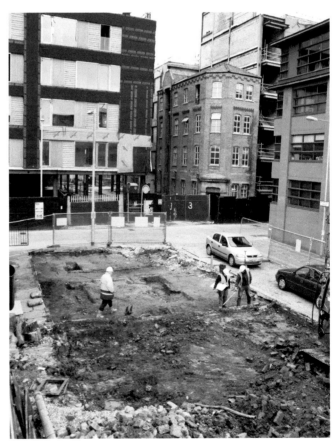

Excavations of workers' housing at Hall's Court, Jersey Street, by the University of Salford in 2011.

IMPROVING DWELLINGS

This period of rapid population growth and increased pressure on housing quality from around 1775 to 1851 was followed in the later nineteenth century by a slow improvement in housing quality through local byelaws that led to the addition of backyard privies, the closure of cellar dwellings and the demolition or conversion of back-to-back houses (Nevell, 2014). This was the result of local government in Manchester assuming a series of powers designed to alleviate or remove the more insanitary conditions in the town's housing, which were the main factor in the cholera and typhoid epidemics of the 1830s and 1840s (Kidd and Wyke 2010). The Manchester Police Act of 1844 banned the building of new back-to-back houses, while new cellar dwellings were made illegal in 1853. Under legislation in 1867 individual back-to-backs were declared unfit for human habitation. To bring them up to the required standard, landlords might create a through-dwelling by knocking doors through the party wall between a pair of back-to-backs. Pairs of back-to-backs or individual one-up-one-downs in the court areas might be removed altogether to create the space for yards for the remaining properties (Kidd, 2002; Roberts, 1993).

Improvements in the living conditions of the industrial suburb could be slow. In 1889 Dr John Thresh presented a paper to the Manchester and Salford Sanitary Association, in which he examined the reasons for the continued high mortality in No. 1 District in Ancoats. This was a 36-acre area between Great Ancoats Street, Oldham Road, Union Street and German Street. Thresh reported the majority of houses in this district (over 800) had been built before 1830, some even before 1780; around sixty had been built between 1830 and 1850, but none after that last date. Most were two storey, but there were several three-storey

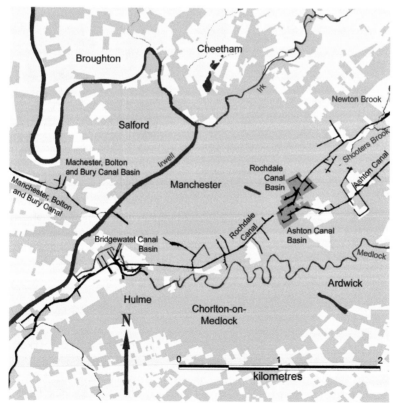

The urban area of Manchester and Salford as recorded by the Ordnance Survey in 1850, showing the location of the canal network.

Above: Surviving nineteenth-century housing on the corner of Jersey Street and Great Ancoats Street. The site of Hall's Court lies behind these buildings.

Right: The exterior of one of Manchester's workshop dwellings, as published by *The Builder* in 1862. By this date such dwellings were being converted into tenement properties.

houses, with a workshop in the garret. Back-to-backs accounted for around a third of the dwellings in the district. Many houses had cellars described as being used as workshops or for storage. In 1904 T. R. Marr, in 'Housing Conditions in Manchester and Salford', reported the results of his own inspection of nearly 600 dwellings in 12.7 acres of No. 1 District. Almost half the dwellings were four roomed (i.e. two-up-two-down), while a third were still two roomed, although these were gradually disappearing under pressure from Manchester's Sanitary Committee (Roberts, 1993). In 2011 the excavation of a set of eight back-to-back houses on the corner of Jersey Street and Pickford Street in Ancoats showed that running water to each house and an individual privy per property were not installed until the early twentieth century, and there was no indication of any form of gas supply (Nevell, 2014).

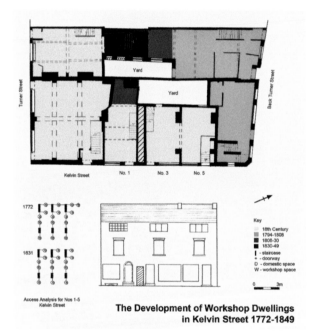

The Development of Workshop Dwellings in Kelvin Street 1772-1849

The development of the fustian workshops on Kelvin Street from 1772 to 1849 showing how the building plot was built up.

Glazed earthenware bowl from the first phase (early nineteenth century) of the Jersey Street back-to-back houses, Manchester.

EARLY TWENTIETH-CENTURY POWERHOUSE

Manchester reached its commercial, industrial and demographic zenith just before the outbreak of the First World War in 1914. As a city of 714,333 people in a wider region of nearly 2.5 million, as recorded in 1911, Manchester was the largest urban area outside London. Cotton spinning was at its peak, and the new ready clothing sector was booming. Manchester's economy was more diverse than ever. It was an international port, exporting not just cotton yarn and cloth, but also machine parts and finished machinery. Its commercial banks played a nationally significant financial role. New manufacturing industries for cars and aeroplanes grew in the industrial suburbs of the city. The city also developed as the most important newspaper centre outside London. This was led by the *Manchester Guardian*, founded in the wake of the Peterloo Massacre of 1819, but was aided by the development of two new forms of rapid communications: the telegraph and telephone. The business use of the telephone was pioneered in Manchester's textile warehouse district, where it was introduced within two years of the technologies commercial launch. Manchester thus remained a city of innovation and dynamism.

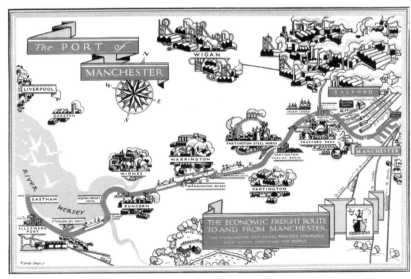

An early twentieth-century advert for the Manchester Ship Canal. (Image courtesy of The Peel Group)

THE PORT OF MANCHESTER

The opening of the Manchester Ship Canal and the Port of Manchester in 1894 transformed the city into an inland port, 58 km (36 miles) from the sea, and marked the final flourish of industrialised water transport. By 1909 the port had nine docks (five of which were within

A view of the early twenty-first-century access between the Bridgewater Canal and the surviving dock at Pomona on the Manchester Ship Canal.

'To the Door of the Mill', a Manchester Ship Canal advertisement from the *Textile Mercury*, 1927. (Image courtesy of The Peel Group)

the city at Pomona) covering 8.8 km (5.5 miles) of wharfs, and had become the sixth busiest port in Britain. In the first two decades of its life the chief imports were grain, cotton and lamp oil from northern America. As the engineering centre of Trafford Park on the opposite bank of the canal grew, finished engineering goods and raw materials for the machine tool sector became important commodities on the canal. Some of these goods were housed in the three types of warehousing on the docks: transhipment sheds, cotton safes and general-purpose concrete stores. Other materials were loaded on the dockside into trains or wagons for immediate distribution. At its peak in the early 1940s, during the Second World War, more than 3,000 dockers worked on the site and briefly in the late 1940s it was the third busiest port in Britain (Nevell & George, 2017).

TEXTILES AND GARMENT MANUFACTURE

Manchester saw little evidence of the Edwardian and post-world war building booms of the 1900s and early 1920s, New Little Mill, built by Murrays in 1908, and the electrically driven Paragon Mill and Royal Mill, both built in 1912 by McConnel & Co. on earlier sites in Ancoats, being notable exceptions. These were the very last textile spinning mills built within the city (Williams with Farnie, 1992). Despite losing large overseas yarn markets in the 1920s, especially in India and Japan, Lancashire remained the centre of factory-spun cotton production down to the Second World War, with Manchester at its commercial heart. A symbol of this was the new Royal Exchange building opened by George V in 1921. There were still over fifty cotton-spinning manufacturing firms within the city on the eve of the financial collapse of 1929 that heralded the Great Depression of the 1930s and a long period of mill closures and unemployment. Yet the industry remained capable of innovation, the establishment of the Calico Printers Association in 1899, an amalgamation of forty-six textile printing companies and thirteen wholesale firms being an example of some of the business restructuring needed to keep Manchester at the heart of the cotton industry. Technical innovation continued, through the introduction of electrically driven machinery and companies working on developing new synthetic fibres throughout the 1930s.

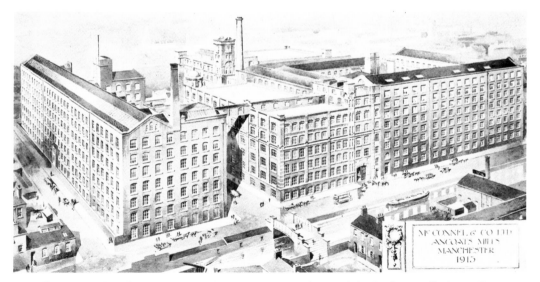

Engraving of McConnel's mills in Ancoats, showing the newly built, electrically driven Paragon and Royal mill blocks, from a letterhead of 1913.

The interior of Royal Mill around 1913 showing the concrete floor. (© Manchester Region Industrial Archaeology Society)

In 1941 scientists at the Calico Printers Association, headquartered in Manchester, developed Terylene, the first polyester fibre (Kidd and Wyke, 2016).

A major addition to the city's textile manufacturing sector was ready-to-wear clothes making. This was enabled by the development of the sewing machine, the first treadle machine being patented by Singer in America in 1851. Manufacture of such machines began in Britain in 1859 and quickly led to the establishment of ready-made clothing firms in many industrial towns. One of the early cotton manufacturers to move into the new clothes making business was the cotton merchant, manufacturer and philanthropist John Rylands (1801–88). From 1843 he developed his father's business of Rylands & Sons into the largest integrated cotton company of the Victorian period, with the firm spinning, weaving, finishing and marketing cotton cloth in its own mills and warehouses. At the company's peak in the early 1880s Rylands employed around 15,000 people with 200,000 spindles and 5,000 looms spread across seventeen mills in Bolton, Bury, Chorley, Manchester, Swinton and Wigan, as well as warehouses along New High Street in Manchester and in London. Its commercial activities brought in more income than its manufacturing concerns (Farnie, 1973). From the late 1860s the firm developed the large-scale manufacture of clothing, especially shirts, on sewing machines based in Longford and Medlock Mills, and later had a clothing factory in Crewe.

Other individuals followed Rylands into the ready clothing trade. By 1900 the Manchester industry was employing more people in the city than cotton spinning. In 1931 this figure had reached over 20,000 workers. Manchester, along with Leeds, became the chief ready clothes making centres of northern England (Kidd & Wyke, 2016; Williams with Farnie, 1992). Most of these clothing companies were based in converted cotton spinning mills in Ancoats and Chorlton-upon-Medlock, such as Brownsfield Mill, which as early as 1870 was given over to such businesses. Four of the very few purpose-built clothing factories erected in Manchester can still be seen on Canal Street. These were built between 1880 and 1900. The grouping

Above left: Calico Printers Association fabrics from 1899 (top) and 1949 (bottom). Manchester's wealth was built on the spinning, weaving and finishing of cotton cloth such as this. (Image courtesy of Tameside Local Studies Library)

Above right: Sign by the entrance to John Rylands Library, Deansgate, Manchester. The library was built with money donated by John Rylands' widow.

The entrance to the John Rylands Library on Deansgate, a monument to one of Manchester's leading Victorian textile entrepeneurs.

includes a five-storey brick building, nine bays long, dominated by large tall windows and horizontal stone bands, which is now No. 10. This was built by the Reynolds Brothers as an underclothing factory, and the firm employed 350 people in 1900. No. 3 Canal Street is four storeys high with large square windows and an attic, and was occupied by William Langford's skirt factory (Nevell & George, 2016).

BICYCLE, CAR AND PLANE MANUFACTURE

The development of the safety bicycle in the 1880s saw a boom in bicycle popularity and use, especially among women. In the late 1880s the Clavier Cycle Company Ltd was established in Manchester in a works on New Bridge Street. In 1889 it changed its name to the Manchester Cycle Manufacturing Company and the following year built a new works in Clayton, known as the Belsize Works. Despite booming sales nationally, the company closed in 1897.

There were a number of horse-drawn carriage makers in Victorian Manchester who branched out into motorcar and body manufacture in the early twentieth century. One such was Cockshoot, which had premises on Major Street. The company was founded by Joseph Cockshoot in 1844. In 1902 it opened one of Britain's first motor vehicle garages on Deansgate. The following year they began making high-quality motorcar bodies, moving to a new factory on Great Ducie Street in 1906. Concentrating on motorcar bodies in 1907, they became the East Lancashire and Cheshire agents for supplying bodies to Rolls-Royce. They continued to make car bodies down to the 1930s but during the Second World War focussed on aircraft components.

The earliest known car manufacturer in Manchester was Marshall & Co., who took over the Belsize bicycle works to make cars in 1897. The company was renamed Belsize Motor Cars & Engineering Company in 1903 and quickly became the leading British motorcar manufacturer, producing up to fifty vehicles a week and employing a workforce of 1,200. The firm adopted some of the mass production techniques used by Henry Ford, who had begun producing cars at the nearby Trafford Park in 1908. After the First World War the company produced cars, lorries and taxicabs but struggled financially in 1923, closing in 1925 (Miller, 2013). The most successful Manchester motorcar manufacture was Crossley's, which was originally a stationary gas engine manufacture. The company began building cars at Gorton in 1904, although Crossley Motors was not set up as a separate company until 1910. One of their

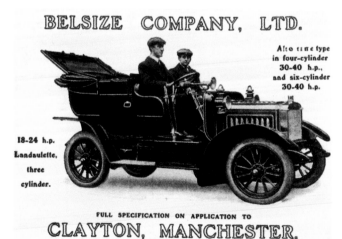

A 1905 advertisement for Belsize cars.

The Clayton motor works of the Belsize car manufacturing company in the 1970s. (© Manchester Region Industrial Archaeology Society)

The engineering works of the Crossley motor company as they survived in the 1970s. (© Manchester Region Industrial Archaeology Society)

An AVRO triplane on display at the Museum of Science and Industry in Manchester.

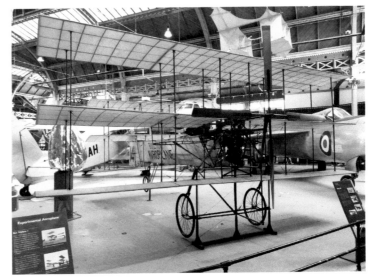

The surviving manufacturing buildings of the AVRO company in the 1970s. (© Manchester Region Industrial Archaeology Society)

most successful models was the Regis 6, 1,050, of which were built between 1935 and 1937. From 1937 the company specialised in commercial vehicles.

Most famously Frederick Henry Royce built his first car at his Cooke Street factory in Hulme, Manchester, in 1904. His second car was used by his business partner Ernest Claremont. It was this car that Royce showed to Charles Rolls at the Midland Hotel in Manchester on 4 May 1904. This led to the setting up of the Rolls-Royce partnership.

One of the British pioneers in aviation was based at Manchester. The first all-British aeroplane to fly was designed by Alliott Verdon Roe and flew in 1909. Born in Salford, he set up a factory with his brother Humphrey in 1910. The workshop was in the basement of Brownsfield cotton mill in Ancoats, the triplanes being assembled elsewhere. In 1919 an Avro 504k biplane was used on Britain's first scheduled airline service from Blackpool to Southport and Manchester. After the First World War production moved to a factory in Newton Heath. The A. V. Roe & Co. would go on to produce the Lancaster and Vulcan bombers, using the Woodford aerodrome near Stockport as their testing ground (George, 1993).

TELECOMMUNICATIONS

Manchester's role as a commercial and transport hub in the nineteenth century put it at the heart of the newly emerging area of telecommunications. The first fully practical electrical telegraph system was demonstrated in 1837 on the London & Birmingham Railway (Liffen, 2013). Thereafter, the development and expansion of the national electrical telegraph network followed that of the railways. The Manchester & Leeds Railway (later the Lancashire & Yorkshire Railway) opened Manchester's first electrical telegraph office at Oldham Road station in 1842. Shortly afterwards the Lancashire & Yorkshire Railway opened their School of Signalling at Victoria station to train operators in the use of the electrical telegraph. By 1852 the English and Irish Magnetic Telegraph Co. was running pubic telegraph offices in the city, allowing news and business to flow more quickly. By the 1860s wire companies such as Richard Johnson & Brother in the Bradford district were manufacturing cable wire. In Worrall's first cotton spinners trade directory, published in 1884, most manufacturing and wholesale firms gave a telegraphic address.

Right: The Manchester office of the Eastern Telegraph company. (Image courtesy of Nigel Ling)

Below: A section through Bedson's continuous wire rod mill, installed at the Bradford Ironworks in 1862.

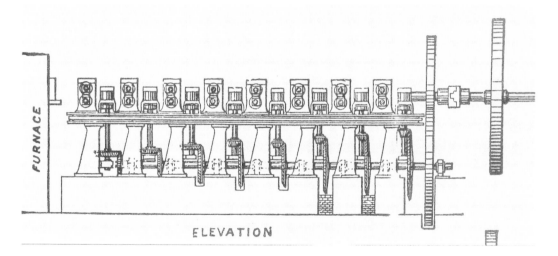

ELEVATION

Manchester was at the forefront of promoting the use of the telephone. Within two years of Alexander Graham Bell submitting his patent for the telephone in the USA, the first telephone installed under licence from the Post Office within the UK was in use in Manchester (Liffen, 2013). In January 1878 two Bell-type telephones were installed, connecting Thomas Hudson's hardware premises on Shudehill and his offices on Dantzic Street. This was typical of early installations in that the telephone simply provided a point-to-point connection. Very soon demand had grown to warrant the establishment of telephone exchanges to provide subscribers with a broader range of interconnection possibilities. Manchester opened one of the first such exchanges in the UK in 1879 at Faulkner Street. These early days of the telephone were typified by small regionally based companies, such as the Lancashire and Cheshire Telephone Company, offering services to business customers. In 1884 permission was granted for these companies to provide general non-subscriber access to the telephone

service through the establishment of public call offices. It took several decades for a fully interconnecting national telephone service to develop and it was not until 1895 that the Post Office acquired the long-distance trunk network of the National Telephone Company. In 1909 Slater's trade directory for Manchester listed public telephone call boxes at various places across the city including on Ashton Old Road, Bury New Road, Hunt's Bank, Rusholme Grove and Wilmslow Road.

Along with the first use of the telephone, Manchester companies were also involved in manufacturing the cable and handsets. By the 1880s Richard Johnson & Nephew were manufacturing telegraph cable at their Bradford Ironworks. In Ardwick at the Dolphin Street Works David Mosely & Sons, who had supplied the equipment for Thomas Hudson, continued their production of insulated cable and handsets throughout the 1880s and into the 1890s. A measure of the rapid uptake of this technology can be seen in Worrall's textile directory for 1900, which included thousands of telephone numbers for Manchester-based firms, where there had been none in the first edition of 1884.

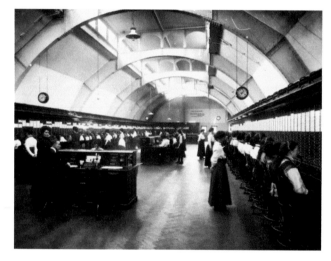

Manchester Central Telephone Exchange around 1900. (© BT Archives)

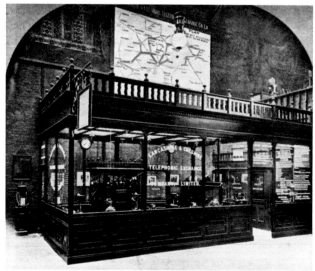

A Lancashire and Cheshire Telephone Company public call office in Manchester around 1910. (Image courtesy of Nigel Linge)

REINVENTING MANCHESTER POST-1945

In 1945, at the end of the Second World War, Manchester's traditional industries of cotton, coal, engineering and transhipment remained at the heart of the working life of the city, though all were in long-term decline. As the country recovered from a wartime economy these manufacturing and distribution industries revived, and briefly in the early 1950s they seemed more robust than they had done for a generation. Yet global markets were changing and with them Manchester itself. By the 1980s these traditional industries had gone or been relocated to other parts of the city region, and Manchester set about reinventing its economy and image and bringing people back into the city. Thus, from a population low of 392,819 in 2001, over the next decade the city grew by a fifth to reach 503,127 people in 2011, and in 2016 the council estimated that Manchester's population as standing at 541,300.

Circular concrete blocks manufactured during the Second World War as anti-tank devices, as excavated at the Castlefield Iron Works in 2016.

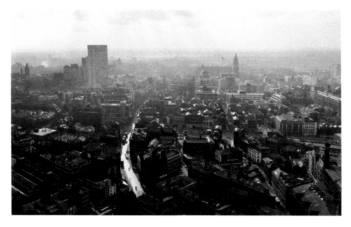

An aerial view of the centre of Manchester in 1966 looking towards the town hall (right) and the CIS building (left). This was a city on the brink of major change. (© Manchester Region Industrial Archaeology Society)

THE FALL AND RISE OF MANCHESTER'S MILLS

After a brief boom in cotton production from 1946 to 1951, Manchester's most iconic industry, textiles, rapidly declined. A. & G. Murray, for instance, ceased yarn production at their Ancoats mills in 1954. By 1958 the UK was a net importer of cotton cloth. The Cotton Industry Act of 1959 was meant to help the industry modernise by encouraging amalgamation and investment in new equipment (Miller & Wild, 2007). In 1965, according to the eightieth edition of Worrall's Lancashire Textile Industry directory, there were just thirty-four cotton companies left within the city: thirteen companies spinning and doubling yarn, thirteen companies finishing cotton cloth, six companies weaving cloth and two cotton waste manufacturers. Faced with increasing overseas competition and the introduction of new manufacturing techniques, virtually all of the Lancashire's cotton mills closed in the 1960s and 1970s. In Manchester, all were gone by the 1970s, only clothes manufacture surviving in the city to the end of the century. Many of these occupied business units in former cotton mills, such as Murrays', where there were three clothing firms in New Mill alone by 1965. When the Manchester-based television company Granada TV devised the new drama *Coronation Street* in 1960, set close to Manchester, the factory at the end of that street was not a cotton mill but a clothing workshop.

The conservation and reuse of city's textile mills and its historic warehouses has been at the heart of the city's reinvention since the 1980s. The first archaeological survey of the mills in the late 1980s found seventy-five still standing within the city (Williams, 1988). This led to twenty receiving listed building status in the 1990s and a drive to find new commercial and domestic uses for the most significant structures. An archaeological re-survey in 2016–17 found just forty-two survived, four-fifths of which are in use, many as apartments or offices. In Ancoats regeneration has been led by the conversion to offices of Murray's mills and to apartments of McConnel's mill. In Chorlton-upon-Medlock the Cambridge Street Mills are now used as student accommodation and many textile warehouses, especially along Princess Street and Portland Street, are now in use as small-unit offices, while other warehouses in Castlefield and around the Rochdale Canal basin have been converted into apartments. The availability of such business and domestic accommodation has been a major factor in reviving the historic city centre, an area covering roughly 5.5 square kms, which includes Castlefield and Ancoats. The population of this areas rose from a low of around 1,500 in 1981 to 11,689 in 2001 and 17,861 in 2011.

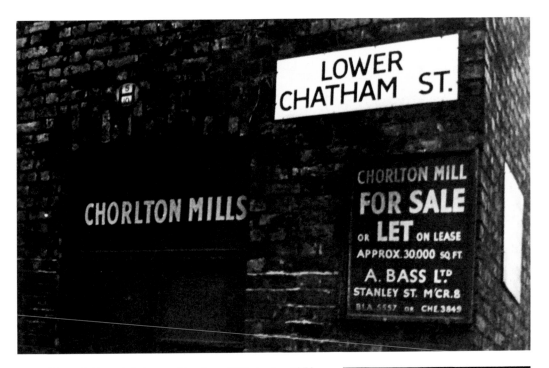

Above: A 'for sale' sign at Chorlton Mills in the 1970s, a symbol of the end of the cotton-spinning industry in the city. (© Manchester Region Industrial Archaeology Society)

Right: A list of garment manufacturing companies occupying Brownsfield Mill in the 1970s. This was the textile sector that lasted longest in the city. (© Manchester Region Industrial Archaeology Society)

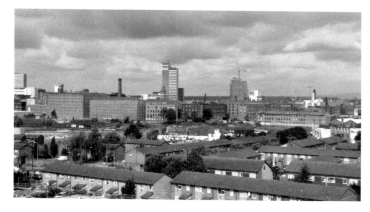

A view of McConnel and Murray's mills in Ancoats, both renovated during the 2000s.

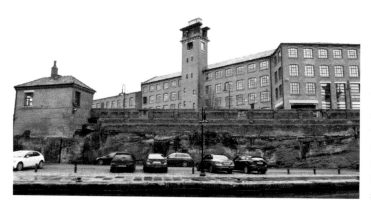

The Castlefield canal basin with, in the background, the regenerated eastern range of the Castlefield Ironworks built around 1850.

FROM SEAPORT TO AIRPORT

Although the economic boom of the early 1950s was reflected by the building of new warehousing at the Port of Manchester, the introduction by the Manchester Liners' Company in the 1960s of containerised shipping to the Salford Docks marked the beginning of the decline of the port. It rapidly became too small for the new ocean-going container ships, and was closed in 1982.

A similar fate seemed to await the city's canals in the mid-twentieth century. The two decades between the nationalisation of the UK canal network in 1948 and the 1968 Transport Act that formally divided canals into commercial, cruising and the remainder (ripe for closure) saw most commercial canal traffic on the Manchester canal system disappear. Unusually, both the Bridgewater Canal and the Rochdale Canal were not nationalised, each remaining in private ownership. Their immediate fates were quite different. Most of the Rochdale was closed as a through route in 1952, except for the nine locks through central Manchester that linked the Bridgewater and Ashton canals. The Bridgewater remained a commercial canal until 1975, thereafter becoming a cruising canal.

The restoration of the British canal network is one of the greatest volunteer restoration stories of the late twentieth century, and the people of Manchester played a very significant role. A bill to close the Rochdale Canal was passed in 1965 on the condition it was maintained

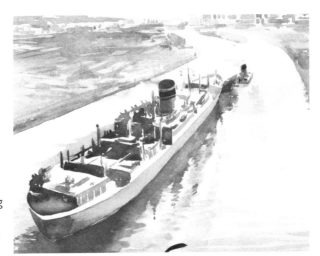

En Route to Manchester, a painting from *c.* 1930 (GB124.B10/ advertisement, GMCRO). (Image courtesy of The Peel Group)

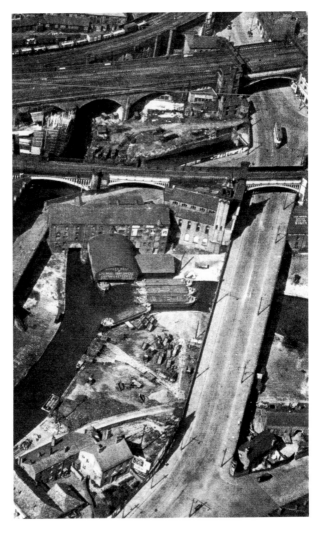

An aerial view of the Castlefield canal basin from around 1950, showing four barges tied up at the Grocers' Warehouse.

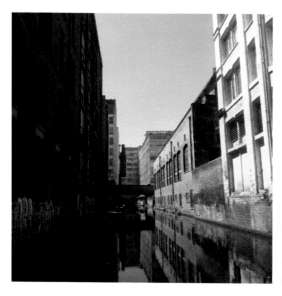

The Rochdale Canal corridor, looking west towards Oxford Street was regenerated during the 1980s and 1990s.

in Manchester until the adjoining Ashton Canal was closed. By this date the nine locks through Manchester from the Ashton Canal to the Bridgewater were almost unusable. That was the signal to start campaigning to save the Ashton and the Rochdale canals. After several years of intensive volunteer work to clear the Ashton's line into the eastern side of the city, and the repairing of the locks and lock gates, the Ashton Canal was reopened in 1974. The year before, in 1973, the Rochdale Canal Society was formed to promote its restoration (Squires, 2008) and the nine locks on the Rochdale Canal between the Ashton Canal junction and the Bridgewater Canal (locks 84 to 92) were repaired and reopened in the late 1970s. The full length of the canal and its ninety-two locks was reopened in 2002 under the ownership of British Waterways (now the Canal and River Trust).

The railway network was in steep decline during the 1960s, which was reflected in the closure of three of Manchester's terminal stations. Exchange station and the Oldham goods station were closed in the years 1968–69, and the sites largely cleared soon after. Central station was closed in 1969, but was bought by the new Greater Manchester Council in the late 1970s and converted into an exhibition centre, reopening in 1985. This, along with the reopening of the Royal Exchange as a theatre in 1976, was an early example of heritage-led regeneration within the city (Parkinson-Bailey, 2000).

The value of the city's industrial heritage in revitalising living and working in the centre of Manchester was shown by the regeneration and restoration of Castlefield. By the early 1970s the Castlefield area, once a regionally and nationally import transport hub, had become neglected due to changes in the location of city centre industries and transport routes. This resulted in many run-down and abandoned buildings, silted canals and overgrown railways viaducts. In 1975 Liverpool Road station closed and the site could have been sold by British Rail for redevelopment. In 1978 the station was bought for £1 by the Greater Manchester County Council with the intention of housing the North West Museum of Science and Industry, then resident on the University of Manchester's campus at Grosvenor Street. The museum, later renamed the Museum of Science and Industry in Manchester (MSI), opened on this site in 1983 and progressive phases of restoration have produced a large site covering a number of acres and incorporating not only the 1830 passenger station but also the 1830 railway

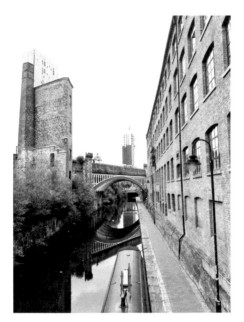

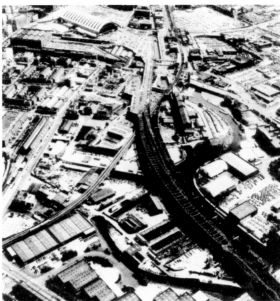

Above left: The Rochdale Canal looking east with the Castlefield Ironworks to the right and Beetham tower on the skyline.

Above right: The railway viaducts of the Castlefield area, looking east, in the 1980s. (Image courtesy of the Greater Manchester Archaeological Advisory Service)

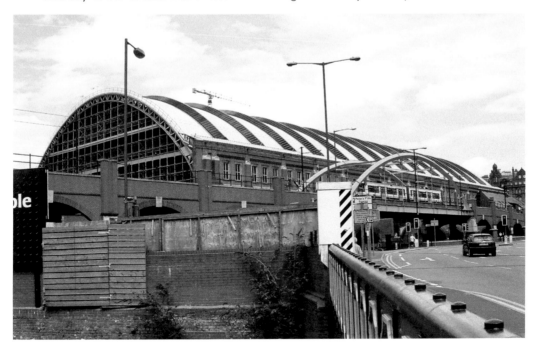

Central station on Windmill Street, built in 1875–80 for the Cheshire Lines Committee and converted into an exhibition centre in the 1980s (now Manchester Central).

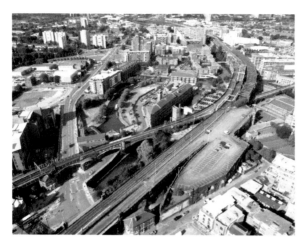

An aerial view of the regenerated Castlefield area in 2008. (Image courtesy of the Greater Manchester Archaeological Advisory Service)

warehouse, the 1855 transfer shed and the 1880s Lower Byrom Street warehouse. Shortly after its reopening work began on transforming the surviving canal warehouses in the basin, the Bridgwater and Merchant's, into housing and offices, as was the Castlefield Ironworks building. Alongside these were built a new public open space and the Roman gardens, the centre of which was the reconstruction in stone of the northern gateway of the Roman fort. This was all part of turning this area into the country's first urban heritage park. When the new Metrolink tram network was opened across the city centre in 1992, running from Bury in the north to Altrincham in the south, Castlefield had its own tram stop.

While the city's industrial transport heritage was a major lever for regeneration in the city centre, its role as a national and international transport hub was reborn with the growth of Manchester Airport at the southern end of the greatly expanded city boundaries. Several aerodrome sites had been used between the two world wars, from Barton and Trafford Park beyond the city boundaries and Alexandra Park and Wythenshawe Aerodrome within them. The decision of the city council in 1934 to establish a municipal airport in the newly acquired district of Ringway was as far-sighted as backing the building of the Manchester Ship Canal fifty years earlier. The first commercial flight was in June 1938 and a few days later KLM began flying the first international route to Schipol in Holland. During the Second World War the site was used by the RAF as a training base, while Fairey Aviation built aircraft at the site. In 1941 two asphalt runways were built.

Returning to civilian use in 1946, by 1947 34,000 people used the airport and the first transatlantic route began in 1953, flying to New York's Idlewild Airport (now JFK Airport). In 1958 the runway extended to 1,800 metres, by which time the airport was handling 500,000 passengers annually. Terminal 1 opened in 1962. Britain's new motorway network, in the form of the M56, had a junction specifically for the airport when it opened in 1972. The main runway was extended to 3,048 metres in 1981 to encourage long-haul flights. The World Freight terminal opened in 1986 and in 1988 the airport handled 9.5 million passengers. The 1990s saw continued expansion. In 1993 Terminal 2 and the airport's own railway station opened, with passenger numbers reaching 15 million in 1995, to be followed by Terminal 3 and the construction of runway 2, which opened in 2001 (Simmons & Caruana, 2001). Further terminal extensions, a new control tower and extension of the Metrolink tram system to the airport followed in 2004. In 2017 27.8 million passengers flew and arrived at Manchester Airport, with a work force of 19,000, making it the third busiest airport in the UK and echoing the early twentieth-century success of the Manchester Ship Canal.

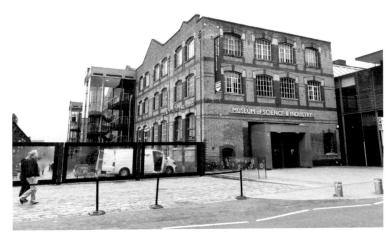

The Byrom Street railway warehouse, converted into a museum as part of the Museum of Science and Industry in Manchester in the 1980s.

Terminal 3 pier at Manchester Airport in 2018 showing an Airbus A380 (centre), the largest passenger aircraft in the world, being prepared for boarding.

COMPUTING, ENGINEERING AND TELECOMS

Heavy engineering in the city largely disappeared during the second half of the twentieth century, its decline hastened by the demise of the steam locomotive in the early 1960s and the associated railway engineering works in Gorton and Openshaw. The last traditional metal forge was the EVA Brothers site at Crabtree Forge by Lock No. 13 on the Ashton Canal in Clayton. The site was established in 1898 and when it closed in 2005 was making specialist car parts and blanks for forging car parts. Although traditional heavy engineering has left the city, specialist engineering continues, such as at Clayton Engineering Ltd. Among the new technologies to emerge in the early twenty-first century are small companies experiment in nanotechnology, the manufacture of small high-tech devices and materials. One such was established in 2005 at the Manchester Incubator Building at University of Manchester – Nanoco Technologies Ltd. They mass-manufacture quantum dots, which are used as low energy pure light sources in a range of products including TV screens and mobile display. In 2004 researchers at the University of Manchester isolated the substance graphene from graphite, a very strong semi-metal version of carbon that conducts electricity very efficiently. Since then the university has established a Graphene Institute and a Graphene Engineering and Innovation Centre in order to develop in partnership with industry applications for this novel material.

The Galloways' engineering logo on a stationary steam engine of the early twentieth century.

The newly built Graphene Institute building at the University of Manchester.

Manchester was one of the centres of the new computer age that emerged after the end of the Second World War. In June 1948 the University of Manchester ran the first programmable computer. Nicknamed Baby, it ran a programme stored in its memory using cathode-ray tubes. This was developed by a team led by Prof. Freddie Williams and Tom Kilburn. This demonstration model was succeeded by the Mark 1, also developed by the team at Manchester Electro-Technical Department and Ferranti company with government funding. Alan Turing wrote the programming manual for the Mark 1 with help from Cicely Popplewell. This, the world's first commercial computer, was manufactured in Ferranti's east Manchester factory and installed in its own lab at the university in February 1951 (Linge, 2013). Kilburn went on to become the head of the UK's first Computer Science department at the University of Manchester in 1964. Ferranti went on to launch Europe's first microchip in 1976.

Manchester's broadcasting history started on 17 May 1922 when Metropolitan-Vickers Company, based in Trafford Park, began transmitting. Partly designed to advertise its manufacture of wireless receivers, the 2ZY station was absorbed into the new British Broadcasting Company in November 1922. In the early 1930s Manchester was chosen as one of the BBC's five regional stations and started the city's link with broadcast media. Manchester's first television studios were setup by the BBC in 1954 at a converted church on Dickenson Road (formerly the home of Mancunian Film Distributors Ltd). The BBC established a second set of studios in Piccadilly. The first purpose-built studios opened on Oxford Road in 1976,

housing both BBC radio and television. These in turn were closed when the BBC moved to new purpose-built studios at Media City in Salford Quays in 2011 (Kidd & Wyke, 2016).

The early work of the BBC and Mancunian Film Distributors Ltd were important factors in the basing of two of the new commercial TV franchises in the city in 1954: ABC Television, based at the Capitol Theatre in Didsbury, which broadcast at the weekends, and Granada TV, which broadcast during the week from its new base on Quay Street. By the time broadcasting began in 1956 there were purpose-built studios on the site and ultimately there were three studios, each of 420 metres square. The red neon 'Granada TV' sign on the roof of the main building, the eight-storey Granada House, quickly became a new landmark in the city. Not only did the company contribute to a distinctively north television voice in the second half of the twentieth century but it helped to lay the foundations for the arrival of independent radio in 1974 and in the 1990s the growth of small-scale production companies in the city. In 2013 Granada Studios, by then part of a single ITV company, moved to new studios at Salford Quays and Trafford Quays (Kidd & Wyke, 2016).

More than ninety-five years of broadcasting history has provided Manchester with a strong independent base and a skilled workforce, supported by media graduates from the city's two universities and from the University Salford.

Higher education emerged in the late twentieth century as a major employer and driver of the city's economy. The University of Manchester and Manchester Metropolitan University can both trace their roots back to the civic university movement and the mechanics' institutes of mid-nineteenth-century Manchester. In 2017 the University of Manchester employed 10,400 staff and had 40,490 students, while Manchester Metropolitan University had 4,400 staff and 33,010 students. With a combined annual turnover of £1.25 billion, this makes the city's university sector one of the largest employers in Manchester, and one of its main economic drivers, reminiscent of the influence of the textile sector in the late nineteenth century. University research on mechanics and medicine are generating new start-up companies and industries, which again feed back into the city's twenty-first-century economy.

Manchester has capitalised on its sporting history. The infrastructure of the Commonwealth Games, held in Manchester in 2002, has not only helped regenerate the Bradford and Gorton areas as the Eastlands district of east Manchester, but has encouraged the development of sports science and sports medicine (Inglis, 2004). Manchester City's new football training grounds now surround the stadium, and are benefitting from this legacy.

The 1960s Granada TV office building between Byrom Street and Water Street in Manchester.

Left: The late Victorian entrance to the University of Manchester, one of the intellectual and economic powerhouses of early twenty-first-century Manchester.

Below: An aerial view of the Etihad football stadium and the surrounding sports facilities in eastern Manchester. (© www. SuaveAirPhotos.co.uk)

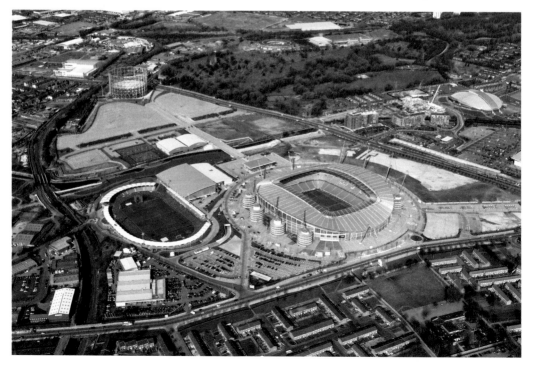

CONCLUSION: WORKING IN THE TWENTY-FIRST-CENTURY CITY

Manchester has always had the ability to reinvent itself. Firstly, as an Elizabethan linen market town, then as a Georgian weaving and market centre for fustian cloth, then as the world's large cotton-spinning town. When the expansion of textile industry in the mid-nineteenth century slowed, Manchester was reinvented as a Victorian commercial and engineering centre and international shipping port. The city was badly affected by the decline in the 1960s and 1970s of the traditional industries of coal mining, engineering, transport and textiles. This culminated in the closure of the Port of Manchester in 1982, and a large drop in its population between 1971 and 1991 to around 404,000. Yet again Manchester set about reinventing itself, this time as an education, music and sports destination on the back of extensive urban regeneration and renewal. In the late twentieth century it reinvented itself by pioneering heritage-led urban regeneration at Castlefield, it rejuvenated its transport network, the Metrolink, allowing fast access to the city centre, while Manchester Airport filled the gap in commerce left by the Ship Canal closure, as well as developing a new international passenger transport industry.

The Bee, a symbol of Manchester's industriousness and strength, has seen renewed popularity since the IRA bombing of 1996.

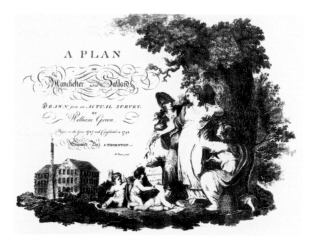

Frontispiece for Greene's map of Manchester, published in 1794, showing Manchester personified as the queen of industry.

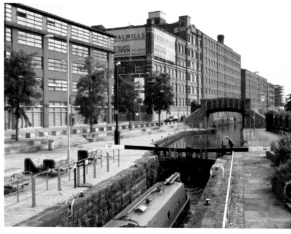

The textile mills of Ancoats, here McConnel's and Murray' alongside the Rochdale Canal, were regenerated in the early 2000s.

The 'Madchester' cultural and music phenomenon of the late 1980s and early 1990s typified the city's reborn confidence, seen after the IRA bomb of 1996 damaged much of the city centre. The lasting legacies of this era can be seen in the alternative culture of the Northern Quarter and the Gay Village, and through city centre regeneration. This led to a surge in people wanting to live in Manchester, the population climbing above 500,000 by 2011. Manufacturing, the city's traditional industrial image, has never entirely left Manchester, and the growth of its two universities in the 1990s and 2000s has brought high technology industry and research back to the city in the early twenty-first century. Of Manchester's working population of 381,500 in 2016, 98,500 (or 26%) people were working in the city centre.

The rhythm of life in the city is now defined by the tram and the mobile phone. Mancunians can now travel into the city centre on the tram while reading their emails on their phones, the working day beginning as soon as they leave their doorsteps. The city's sporting traditions, especially football, provide an ever-increasing attraction for visitors. The local historian and social commentator Thomas Aikin claimed in 1795 that Manchester 'has now in every respect assumed the style and manners of one of the commercial capitals of Europe' (Aikin, 1795: 194). Over 200 years later this remains as true of the early twenty-first-century city as it was of the late eighteenth-century industrial town.

The immediate aftermath of the IRA bomb in 1996, showing the damage around the heart of the explosion on Cross Street.

Manchester's skyline in 2017, as seen from the Salford bank of the River Irwell, is dominated by cranes and a growing band of skyscrapers.

Left: A Manchester tram in Albert Square, one of a new fleet of vehicles introduced when the second tram crossing through the city was opened in 2016.

Below: The regeneration of the Castlefield canal basin and the southern end of Deansgate with its towers have been a catalyst for Manchester's renewal.

BIBLIOGRAPHY

Aikin, J., *A Description of the Country Thirty to Forty Miles round Manchester* (London, 1795)

Ashton, J., *The Manchester Guide: A Brief Historical Description of the Towns of Manchester and Salford, the Public Buildings and the Charitable and Literary Institutions* (Manchester, 1804)

Bradshaw, L. D., *Visitors to Manchester. A Selection of British and Foreign Visitors' Descriptions of Manchester from c. 1538–1865* (Neil Richardson Publications, 1987)

Byrom, R., *William Fairbairn: The Experimental Engineer. A Study in Nineteenth-century Engineering* (Railway & Canal Historical Society, 2017)

Engels, F., *The Condition of the Working Class in England.* (London: Penguin Books, 1845 (reprinted 2005)).

Farnie, D. A., 'John Rylands of Manchester', *Bulletin of the John Rylands University Library of Manchester* 56.1, 93–129 (1973)

George, A. D., 'A. V. Roe and the Brownsfield Mill', *Manchester Region History Review* 3: 93-7 (1993)

Gregory, R., *Roman Manchester: The University of Manchester's Excavations within the Vicus 2001–05* (Oxford: Oxbow Books, 2007)

Hartwell, C., *Pevsner Architectural Guides: Manchester* (London: Penguin Books, 2001)

Hartwell, C., Hyde, M., and Pevsner, N., *The Buildings of England: Lancashire: Manchester and the South-East* (London: Yale University Press, 2004)

Hayes, L., *Greater Manchester's Past Revealed 11: Iron and Steel in Openshaw. Excavating John Ashbury's Carriage and Iron Works* (Aylesbury SLR Consulting Ltd, 2014)

Hills, R. L., *Richard Roberts: Life and Inventions 1789–1864* (2002)

Inglis, S., *Played in Manchester: The Architectural Heritage of a City at Play* (London: English Heritage, 2004)

Kidd, A., *Manchester* (3rd ed) (Edinburgh: Edinburgh University Press, 2002)

Kidd, A. & Wyke, T. (eds.), *Manchester: Making the Modern City* (Liverpool University Press, 2016)

Liffen, J., 'Telegraphy and Telephones', *Industrial Archaeology Review* 35.1, 22–39 (2013)

Little, S., 'The Mills of McConnell and Kennedy, Fine Cotton Spinners', Transactions of the Lancashire & Cheshire Antiquarian Society vol. 104, 35–60 (2009)

Linge, N., 'The Archaeology of the Communications' Digital Age', *Industrial Archaeology Review* 35.1, 35–64 (2013)

McNeil, R., 'The 1830 Warehouse—An Old Model for a New System' in D. Brumhead and T. Wyke (eds.), *Moving Manchester: Aspects of the History of Transport in the City and Region since 1700* (Manchester: Lancashire and Cheshire Antiquarian Society, 2004), 91–101.

McNeil, R., 'Manchester: Symbol or Model for the World?' in A. Green and R. Leech (eds.), *Cities in the World, 1500–2000: Papers Given at the Conference of the Society for Post-Medieval Archaeology, April 2002* (Leeds: Maney, 2006), 151–166.

Maw, P., Wyke, T., and Kidd, A., 'Warehouses, Wharves and Transport Infrastructure in Manchester during the Industrial Revolution: The Rochdale Canal Company's Piccadilly Basin, 1792–1856.' *Industrial Archaeology Review* 31.1, 20–33 (2009)

Miller, I., 'Percival, Vickers & C. Ltd; The Archaeology of a Nineteenth-Century Manchester Flint Glass Works', *Industrial Archaeology Review* 29.1, 13–50 (2007)

Miller, I., *Greater Manchester's Past Revealed 4: Rediscovering Bradford. Archaeology in the Engine Room of Manchester* (Oxford: Oxford Archaeology, 2011)

Miller, I., *Greater Manchester's Past Revealed 9: Coal, Cotton, and Chemicals. The Industrial Archaeology of Clayton* (Oxford: Oxford Archaeology, 2013)

Miller, I. & Glithero J., 'Richard Arkwright's Shudehill Mill: The Archaeology of Manchester's First Steampowered Cotton Mill', *Industrial Archaeology Review* 38.2, 98–118 (2016)

Miller, I. & Wild, C., *A & G Murray and the Cotton Mills of Ancoats* (Lancaster Imprints 13, Oxford Archaeology North, 2007)

Miller, I., Wild, C., and Gregory, R., *Greater Manchester's Past Revealed 1: Piccadilly Place: Uncovering Manchester's Industrial Origins* (Oxford: Oxford Archaeology, 2010)

Musson, A. E., 'Peel Williams & Peel', *Transactions of the Lancashire & Cheshire Antiquarian Society* vol. LXIX, 113–15 (1960)

Nevell, M., 'The Archaeology of the Canal Warehouses of North-West England and the Social Archaeology of Industrialisation', *Industrial Archaeology Review* 25.1, 43–58 (2003)

Nevell, M., 'The Social Archaeology of Industrialisation: The Example of Manchester During the Seventeenth and Eighteenth Centuries' in E. C. Casella and J. Symonds (eds.), *Industrial Archaeology: Future Directions* (New York: Springer, 2005), 177–204.

Nevell, M., *Manchester: The Hidden History* (Stroud: The History Press, 2008)

Nevell, M., 'Living in the Industrial City: Housing Quality, Land Ownership and the Archaeological Evidence from Industrial Manchester, 1740–1850', *International Journal of Historical Archaeology* 15m 594–606 (2011)

Nevell, M., 'Bridgewater: The Archaeology of the First Arterial Industrial Canal', *Industrial Archaeology Review* 35(1), 1–21 (2013)

Nevell, M., 'Legislation and Reality: The Archaeological Evidence for Sanitation and Housing Quality in Urban Workers' Housing in the Ancoats Area of Manchester Between 1800 and 1950', *Industrial Archaeology Review* 36(1), 48–74 (2014)

Nevell, M. & George, D., *Walking the Bridgewater. Exploring Manchester's First Canal* (Birstall: University of Salford Centre for Applied Archaeology, 2016)

Nevell, M. & George, D., *Recapturing the Past of Salford Quays. The Industrial Archaeology of the Manchester and Salford Docks* (Birstall: University of Salford Centre for Applied Archaeology, 2017)

Palmer, M., 'The Workshop: Type of Building or Method of Work?' in P. S. Barnwell, M. Palmer, and M. Airs (eds.), *The Vernacular Workshop: From Craft to Industry, 1400–1900.* CBA Research Report No. 140 (York: Council for British Archaeology, 2004)

Parkinson-Bailey, J. J., *Manchester. An Architectural History.* (Manchester University Press, 2000)

Redhead, N., 'The Archaeology of the Bridgewater Canal at Castlefield and Worsley: Some Case Studies.' in M. Nevell and T. Wyke (eds.), *Bridgewater 250: The Archaeology of the World's First Industrial Canal* (Salford: University of Salford Centre for Applied Archaeology, 2011) 63–76.

Roberts, J., 'The Residential Development of Ancoats', *Manchester Region History Review 7*, 15–26 (1993)

Rose, M. E. with Falconer, K., and Holder, J., *Ancoats: Cradle of industrialisation* (Swindon: English Heritage, 2011)

Simmons, C., and Caruana, V., 'Enterprising Local Government – Policy, Prestige and Manchester Airport, 1929–82', *Journal of Transport History* vol. 22.2, 126–46 (2001)

Southey R., *Letters from England: By Don Manuel Alvarez Espriella. Volume 2* (2nd ed. (London, 1808, reprinted 1951)

Squires R., *Britain's Restored Canals.* (Landmark Publishing, 2008)

Taylor, S., Cooper, M., and Barnwell, P. S., *Manchester: The Warehouse Legacy: An Introduction and Guide* (London: English, 2002).

Taylor, S. and Holder, J., *Manchester's Northern Quarter. The Greater Meer Village* (Swindon: English Heritage, 2008)

Williams, M., with Farnie, D., *Cotton Mills in Greater Manchester* (Lancaster: Carnegie Publishing Ltd, 1992)

ACKNOWLEDGEMENTS

I'd like to especially thank the staff of Salford Archaeology, based at University of Salford, and the many other archaeological contractors who have worked to uncover the city's archaeological past over the last decade. I would also like to thank Nigel Linge, professor of telecommunications at University of Salford, for his help with the telegraphy and telephone section of the book; David George, former Chair of MRIAS, for his continuing advice on the engineering and textile history of the city; Ian Miller for advice on some of the images; and Norman Redhead of the Greater Manchester Archaeological Advisory Service for his support, ideas and tireless promotion of the city's archaeology. Finally, thanks to Catherine Mackey, who provided assistance with editing the final text.

Unless otherwise stated all images are copyright of the author.